1983

# Casting techniques for sculpture

# Casting techniques for sculpture

## Glynis Beecroft

Charles Scribner's Sons · New York

1 3 5 7 9 11 13 15 17 19 I/C 20 18 16 14 12 10 8 6 4 2

Printed in Great Britain
Library of Congress Catalog Card Number 79-63221

**Library of Congress Cataloging in Publication Data**

Beecroft, Glynis.
  Casting techniques for sculpture.

  Bibliography: p.
  Includes index.
  1. Modeling.   2. Plaster casts.   3. Sculpture –
Technique.   I. Title.
NB1185.B43        731.4'5        79-63221
ISBN 0-684-16249-0

To Simon and Nicholas

# Contents

Wherever possible I have given weights and measures in both metric and Imperial units. In some cases this conversion is approximate.

# Acknowledgment

I should like to thank the following people for their professional help and assistance in the preparation of this book:

Robert Owen for checking details and for reading the manuscript; Hunter Cordiay for developing and printing the photographic material; Norman Pierce FRBS, ARCA, SPS, for his skill and patience while I photographed the casting of the portrait head in bronze resin; John Tiranti FRSA for his generous help and technical advice; Willi Soukop RA, FRBS for making it possible for me to take photographs at the Royal Academy School, London, and Damon Rawnsley for allowing me to photograph the stages of casting in silicone rubber; Philip Jackson, of David Gillespie Associates Limited, for making arrangements for me to photograph the glass fibre mould, and Howard Evans for his help and advice while I photographed him at work on the casting; Mr R A J Evans, Headmaster of Clanfield County Junior School, for allowing me to work with groups of children on casting projects; Jennifer Holmes for typing the manuscript. Finally, I would like to thank Thelma M Nye of Batsford for her valuable advice and encouragement.

G M B Hampshire, 1979

# Introduction

I have aimed in this book to describe as simply as possible, a wide range of materials that is easily and cheaply available for use in casting sculpture and to give advice on which process is appropriate for particular sculptures. I have restricted the range of materials and techniques to those that may be used in the home or studio without specialized equipment. I have not attempted to give any guidance on the aesthetics of sculpture. There are many books covering aspects of the history and background of sculpture and I have listed some of these in the Bibliography.

To learn casting techniques from a book presents two main problems. Firstly, photographs and diagrams cannot convey all the available information about what is essentially a three dimensional activity; I hope that an ample number of illustrations of each process will help to overcome this problem. Secondly, every cast sculpture presents a unique set of conditions. As every sculpture is different in shape and form, the casting procedure has to be tailored to the particular piece of work. It is not possible to cover every technical problem that might arise, but by including sections on casting a portrait head, a seated figure, a group of figures, a horse, a solid abstract form and relief panels, I hope that the beginner may acquire a basis on which to learn and develop techniques of casting.

There are no strict rules for casting sculpture. I have consulted many experts and was often surprised by the differences of opinion on certain techniques. Experience is one of the main ingredients in making successful casts and this experience must be built up from solid foundations. The book is arranged with this approach in mind. The first chapters deal with casting techniques which are simple but effective. They form the basis for understanding the more complicated techniques, dealt with in subsequent chapters.

An important consideration is to find a suitable working area. An outhouse, studio or workshop is the ideal place. Nevertheless, when the interest is sufficiently strong it is surprising how enterprising people are. A student I teach does all her casting in a spare room. She lines part of it with large sheets of polythene to protect the walls and the furniture. Another student has found that a greenhouse makes an ideal studio. It is light, has built-in benches and a bath containing water. In cold weather she turns on the greenhouse heater! The discipline of having to work as cleanly as possible is not a bad thing when casting. When none of these facilities is available, the only solution is to be a seasonal sculptor, wait until the good weather comes and work outside.

# 1 Introducing casting

## What is casting?

For the purposes of this book, the term 'casting' is used to describe the mechanical process by which a sculptor makes one or several copies from an original piece of work. The essential feature of the process is the making of a negative copy of the original, or model. This is called the *mould*. The mould is then filled with a substance which has the property of setting hard. When it has set, it is removed from the mould. It duplicates the features of the original and is called a cast.

## Why make casts?

Most sculptors have a preference for a particular sculpture material. Some sculptors choose to work mainly in wood or stone. Here they are working on the original and because the material is hard and permanent they do not have to concern themselves with casting techniques. Many sculptors enjoy the more plastic, malleable qualities of clay, plasticine or wax. Although they are able to achieve an unlimited variety of shapes and textures, the finished model is not durable. A way of preserving the sculpture is to cast it, by means of a mould, into a hard, permanent material.

11

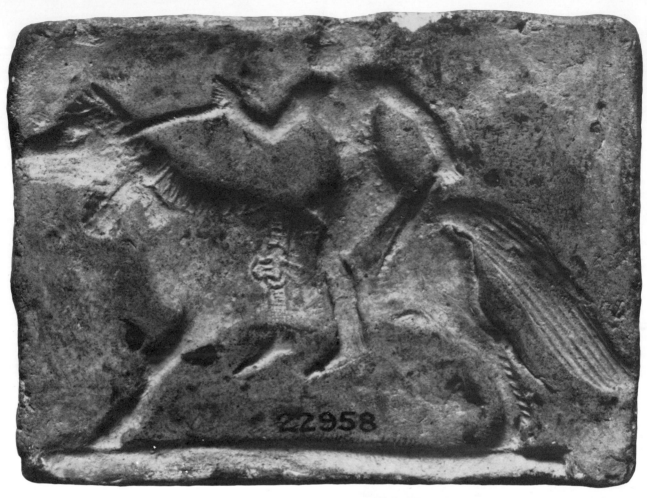

*Terracotta mould and plaque.*
*Old Babylonian, 1800 BC. British Museum, London*

The earliest and most primitive type of mould is the open mould. A wide variety of small baked clay figures and plaques were produced by this method. In ancient Assyria and Babylonia many of these were produced by making an open terracotta mould into which clay could be pressed to make a press casting. As baked clay figures were in constant demand for ritual and temple practices, they could be mass-produced by potters and then perhaps traded over long distances.

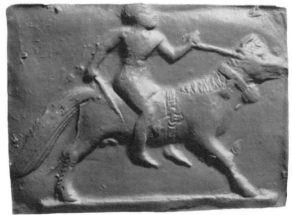

*Stone moulds for jewellery from Nimrud,*
*Kuyunjik and Abu Habba. British Museum, London*

Open moulds were also used for casting simple jewellery.
Designs were cut into the soft stone and molten metal
poured into the recesses and allowed to solidify

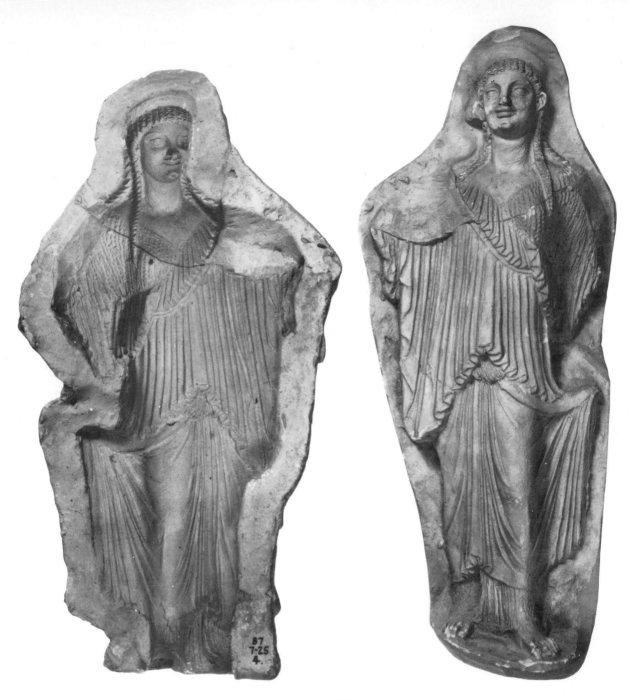

*Clay Mould, Hellenistic.*
*A modern plaster cast taken from the mould is also shown.*
*From Tarentum. British Museum, London*

The Greeks made press castings from open terracotta moulds. Flat-backed terracotta plaques could then be produced in large numbers

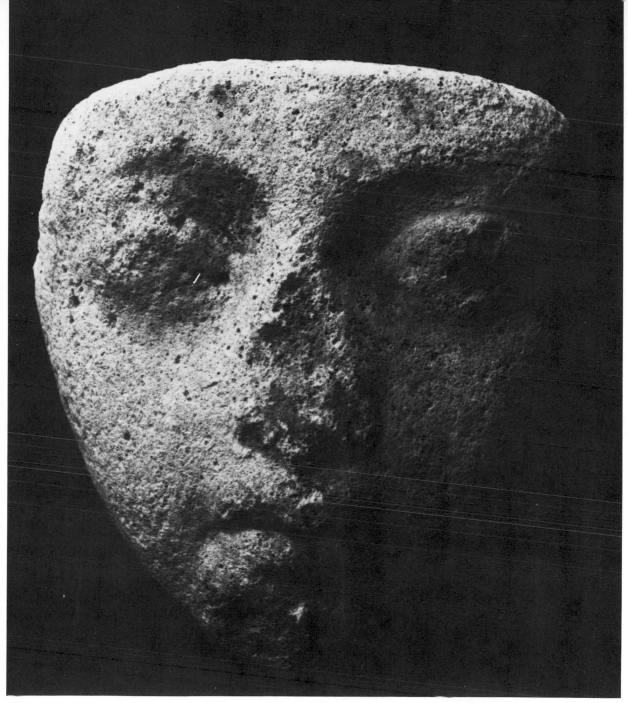

*Egyptian plaster cast taken from life.*
*Amarna period, 1350 BC. British Museum, London*

Gypsum, a form of plaster, has been used by most civilized cultures. It was used by the Greeks and Egyptians for modelling and casting purposes. Egyptian sculptors used plaster to make life and death masks. These casts were used by the sculptor for reference when carving a monumental portrait

*Stone mould for tools: from Chagar Bazar, 2400 to 2100 BC. British Museum, London*

The skill of metal casting has been developed by most civilizations. Some of the earliest examples of metal casting were made by primitive man in order to make spear and arrow heads. This was done by carving the negative shape in a piece of soft stone and then pouring in the molten metal.

Later, more complicated moulds were made in several pieces for casting spear heads and other artefacts in wax before casting them in metal. This forms the basis of the bronze casting technique known as the *lost wax process*. By this method, a large number of the same object could be cast in metal.

This type of mould would have been used for the first stage in the manufacture of bronze arrowheads. Wax would be heated to a liquid state and poured into the mould. When cool and set hard, the wax arrowheads could be removed from the mould and then cleaned and trimmed. They would then be joined together so that a number could be cast in one bronze pouring. Clay would then be packed around them to form a new mould. When the clay was fired, the wax would run out of the mould and the molten bronze could then be poured in to take its place. Once the bronze had cooled and hardened, the clay mould could be broken apart and the bronze arrowheads extracted.

Traditionally, bronze has been the main material for making cast sculpture, because of its permanence and durability, as well as for aesthetic reasons. In some civilizations, the understanding of bronze casting reached a high degree of sophistication. During the Renaissance, bronze statues were made to monumental proportions. Bronze casting is a complicated process and requires specialized equipment. More recently some colleges and professional sculptors have invested in setting up their own foundries, but generally, sculptors find it necessary to send sculpture to be cast by specialists. Unfortunately, this is expensive. With the development of new materials, the sculptor has many alternatives to bronze casting. There is a wide choice of materials available that includes cement, resin, foamed plastic and flexible rubber. A sculptor is now able to model his work and cast it in his studio with the minimum of equipment. With the correct mixture of polyester resin and metal powder, it is even possible to achieve a simulated finish that can be mistaken for real metal. A sculptor may also cast his work when he requires more than one copy of the same sculpture. To keep prices as low as possible, an edition of several identical sculptures can be a more economic venture than making just one original.

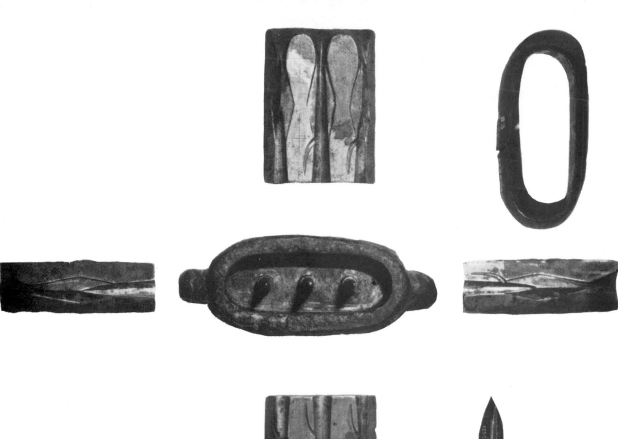

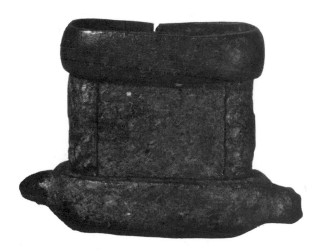

*Bronze arrowhead mould used for making winged arrowheads. Probably sixth century BC. From the Mosul region of North Iraq. The photograph shows the pieces of the mould before it is assembled. British Museum, London*

*The assembled mould*

## Making the mould

There are two main categories of mould used in sculpture. In one, the original sculpture is impressed into a malleable substance, such as clay or damp sand. On removing the sculpture, the features of the original are exactly reproduced in negative form in the clay or sand. In the second category, the model is encased in a substance that sets. Plaster of paris is the commonest material of this type, though polyester resin and various rubber compounds work in the same way.

## Removing the model from the mould

At this stage it is sufficient to say that there are two principle ways of removing the original work from the mould. One way is to gouge out the model, leaving the mould intact. The other way is to construct the mould in several pieces. Each piece can then be prised away from the model and subsequently re-assembled. In the first method the original is destroyed, while in the second method the original can be preserved in one piece.

## Filling the mould

The mould is filled with a substance which sets hard, such as plaster, cement or polyester resin. It is sometimes necessary to coat the inner surface of the mould with a release agent to prevent the cast adhering to the mould. The principal is the same as greasing a cake tin. Some release agents commonly used are soap, wax polish, clay, water and oil. Casts may be made either in the same material as the original, such as a plaster carving cast into plaster, or in an entirely different material, such as a model made in clay and cast into plaster, cement, plastic stone, glass fibre and polyester resin, or metal. The material used depends on the sculptor's requirements. Further information on model and mould making materials and the appropriate release agents, is given in Chapter 5.

## Removing the cast

The way a cast is removed from a mould depends on the shape of the sculpture, as well as on the material from which the mould is made. For example, a cast could be lifted out of a soft clay or damp sand mould without any difficulty, whereas a plaster of paris mould might have to be chipped away carefully from the cast. In some cases it is possible to remove the cast simply by dismantling the mould, which is made in several pieces. With rubber moulds, removing the cast is even simpler. The mould can be stretched, and even cut in places, so that the cast can be eased out.

## Cleaning the cast

Most casts need a certain amount of attention after removal from the mould. The surface is often marred by blemishes. It may contain 'pin holes' caused by trapped air bubbles; parts of the cast may be missing if the mould has not been properly filled; and the surface of the cast may have a bloom caused by the release agent. Beginners are often worried by these apparent imperfections in their casts. They should remember that very few casts made by professional or amateur sculptors are perfect when they first come out of the mould, so cleaning up the cast is an integral and important aspect of the casting procedure.

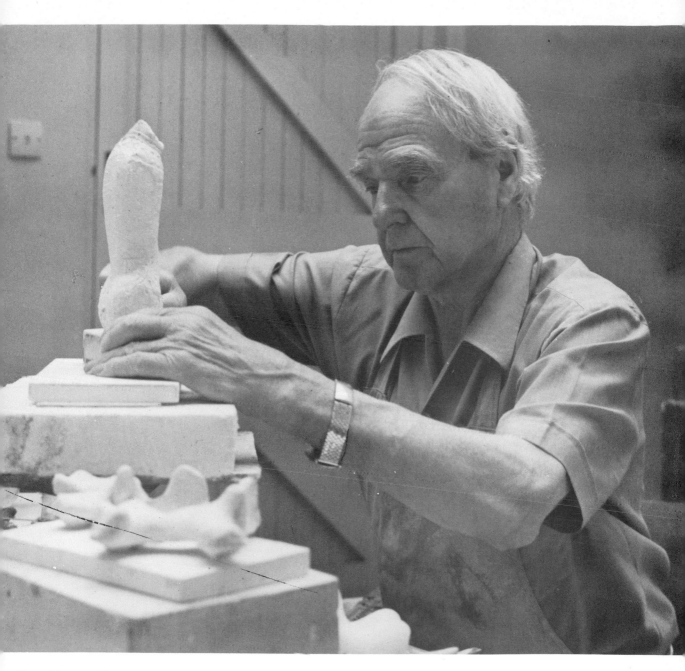

*Henry Moore working in his studio*

# 2  The materials for casting

In the majority of casting processes there are three distinct stages. Firstly, the model has to be made. Secondly, a mould is made from the model. Finally the cast is taken from the mould. This chapter deals with some of the main materials used in these three stages.

## Materials for making the model

### Clay
Clay is the most widely used material for modelling.

It can be obtained from art shops, sculpture and pottery suppliers, usually in 25 kg bags (see suppliers' list). Clay used for pottery must be free of impurities, whereas any clay can be used for sculpture.

It can be bought in varying shades of brown and grey. Some sculptors have a preference for a particular colour. A light-coloured clay, for example, reflects the light and makes it easier to see the form. The important thing is that the clay should have a smooth, malleable consistency and that it should not contain any bits of plaster. If it is too sticky or too hard, it is very difficult to work. Clay is far too expensive these days to throw away if it becomes unworkable. The measures described on page 29 show how to return unworkable clay to a more malleable state.

*A life class modelling in clay
at Southampton College of Art*

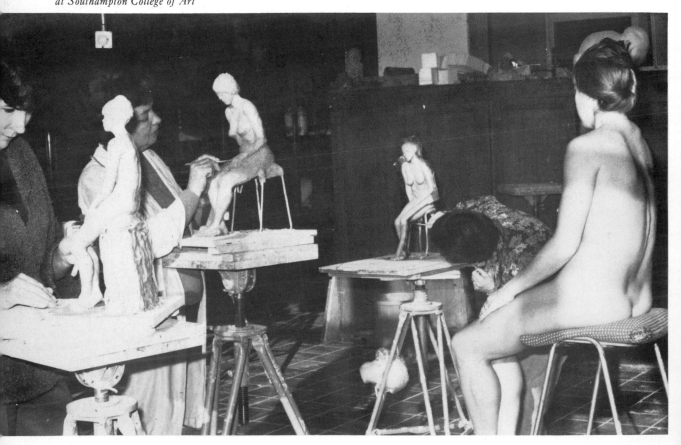

## Plaster of paris

Plaster of paris is manufactured by heating gypsum (a mineral formed by the deposition of salts in inland lakes during the course of many geological periods) to a high temperature, which partially calcinates and dehydrates it. When the powder is mixed with sufficient water to form a mass of creamy consistency, the chemical reaction causes it to thicken and to set hard. Plaster has a wide range of uses. It can be modelled by building up the sculpture or it can be made into a block and carved. Plaster can be obtained from art and craft suppliers, builders' merchants and some of the larger chemists. There are a number of different grades of plaster. Dental plaster has a short setting time (about 7 minutes) which enables the sculptor to work at a reasonable pace. Casting plaster has a longer setting time (15–30 minutes), which can be rather tedious when modelling a sculpture, but in other respects it is similar to dental plaster. *Herculite* and *Crystacal* are very hard plasters for pouring into the mould to make the cast.

Walking Woman *by Giacometti. Plaster. Tate Gallery, London*

Hercules and Cacus? *by or after Michelangelo,*
*first half of sixteenth century. Wax. Height, 45 cm.*
*Victoria and Albert Museum, London*

## Wax

There are many different types of wax. *Paraffin* and *microcrystalline* wax are those most commonly used in sculpture. Both are petroleum-based. They are available in a variety of hardnesses. It is important when buying wax to obtain the correct type. Sculpture suppliers and candle-making stockists give details in their catalogues (see suppliers' list). Wax can be modelled or carved. It is a clean, cheap and easily obtainable sculpture material. A further advantage is that it can be melted out of moulds and re-used.

## Expanded polystyrene and expanded polyurethane

These are extremely lightweight foamed plastics, widely used in industry for packing and insulation. They are also useful materials for sculpture as they can be cut with a serrated knife (for example a bread saw) or with a hacksaw blade. They can also be cut with a heated wire (purpose-made ones may be bought from craft suppliers). Both expanded polystyrene and expanded polyurethane can be joined with certain adhesives, but check when buying an adhesive that it is suitable, as some dissolve the foamed plastic. Most white, water-soluble glues are satisfactory (for example, PVA glues and *Unibond*).

There are certain differences between the two types of foamed plastic. *Expanded polystyrene* is widely used for packaging and it is easy to obtain. It is composed of small bead-like granules and is rather resistant when cut with a knife, but it cuts easily with a heated wire. It cannot be painted with either gloss paint or polyester resin because they dissolve the surface. To prevent this, the surface of the expanded polystyrene must be prepared by sealing it completely with several coats of emulsion paint. *Expanded polyurethane* is generally considered to be the more versatile of the two materials as it is a compact foam that can easily be cut, filed or rubbed with glasspaper. It can be coated with polyester resin to give it a hard, resistant surface.

## Plasticine

This material is widely used in schools and has several advantages. It is cleaner than clay, it does not dry out, and it is always ready for use. On the other hand, plasticine is not easily worked. It needs greater hand pressure than clay to ensure good adhesion, which makes it difficult to achieve subtle effects. However, it is often used by sculptors when experimenting with ideas in the form of small sketch models.

*Blocks of expanded polystyrene and expanded polyurethane*

# Materials for making moulds

### Plaster

This is the most commonly used material in mould making. Its great advantage is that, after mixing with water, it can be applied as a thick, creamy coating to the original sculpture. It sets hard and can be removed as a strong, solid casing, containing the shape of the sculpture in negative form. A further advantage is that the plaster is sufficiently brittle to be easily chipped or cracked away from the final cast.

### Hot melt compounds

Hot melt compounds, such as *Vinamold* (registered trademark of Vinatex Ltd) and *Gelflex*, are vinyl-based castable materials. They are used to make flexible moulds for casting in plaster, polyester resin, and concrete. *Vinamold* is available in several grades of hardness. The compounds are solid at room temperature, so they must be heated to melt down to a liquid before use. The hot liquid is poured around the sculpture and allowed to cool and solidify. A number of casts can then be made from one mould, which may be re-melted many times and used again.

### Cold cure silicone rubbers

There are a number of room-temperature curing silicone rubbers available for mould making. The silicone rubber is mixed with a catalyst before it is applied to the surface of the sculpture. The rubber sets solid after a period of time, which depends on the catalyst used and may vary from 20 minutes to 48 hours.

### Latex

This type of rubber is bought in the form of a thin, milky liquid that can be applied to the surface of the sculpture before being allowed to dry slowly and then baked hard in an oven (a domestic oven is suitable). Multiple casts can be made from this type of mould. This material cannot be re-melted and used again.

### Polyester resin

This is a syrupy liquid that sets after the addition of a catalyst. Resin has no strength when used on its own, so has to be reinforced with a type of woven cloth made of glass strands. This is called chopped strand mat (glass fibre).

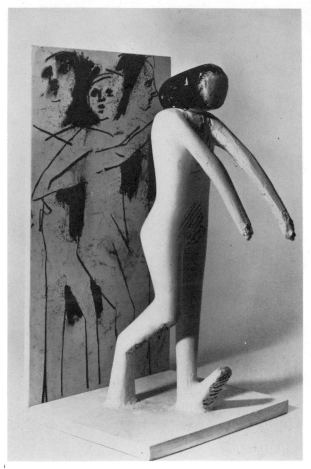

Single figure with drawing, *1972, Kenneth Armitage. Wood, plaster and paper*

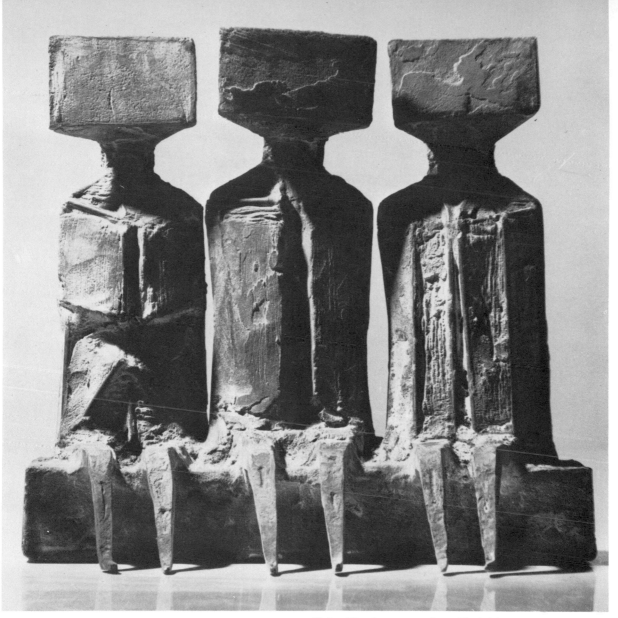

Sitting Watchers, *1975, Lynn Chadwick.*
*This sculpture was made by modelling* Stolit *over a welded*
*metal structure. It was then cast into bronze*

# Materials for making casts

### Plaster
Plaster is frequently used. If the mould is also of plaster, a colouring agent is needed to distinguish them. There are a number of grades of plaster manufactured in a variety of hardnesses. *Crystacal* and *Herculite* are among the hardest and most durable for making casts. Usually an application of some type of colour is necessary to mask the whiteness of the plaster (see finishes for plaster casts, page 110). Plaster is unsuitable for outdoor sculpture.

### Stolit
This is a plaster-based material that is mixed in a similar way to plaster of paris. It is very hard when set, and is available in a rust colour and a terracotta colour (see suppliers' list). When ordering, the two colours are listed as 'white' and 'red'. The rust coloured *Stolit* is a whitish coloured powder containing iron filings. It gradually turns to a rust colour as it dries out and the iron filings oxidise. Like plaster, it is unsuitable for outdoor use.

### Ciment fondu
This is a type of cement which is popular for its quick-setting quality and for the dark grey or bronze-like sheen that can be achieved on the surface of the cast. It is also manufactured in white. *Ciment fondu* is obtainable from builders' merchants and is fairly reasonable in price. It sets very hard and stands up well to outdoor use.

### Concrete
Ordinary Portland cement, which is grey in colour, may be combined with sand, stones and water to make concrete for filling moulds. For a finer surface, many sculptors prefer to use white Portland cement. This is more expensive, but if combined with a stone or marble dust, a reconstituted stone effect can be achieved. Sculpture in this material is suitable for outdoor use.

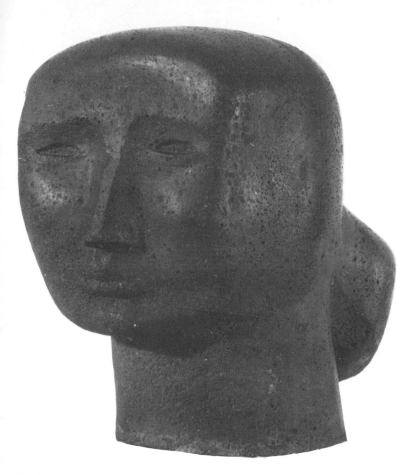

Head of a woman, *1926, Henry Moore.*
*Cast concrete. Wakefield City Art Gallery and Museum*

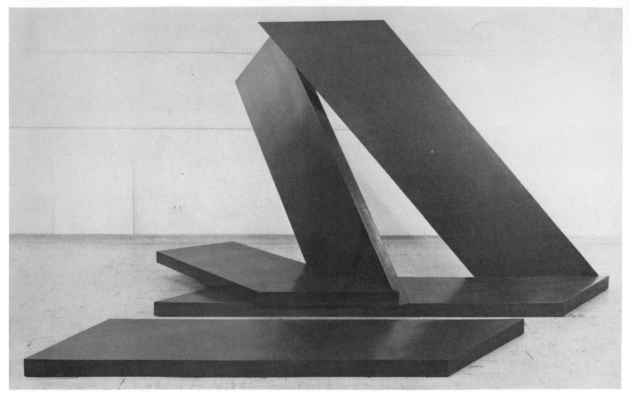

## Polyester resin

This is one of the more recent additions to the sculptor's range of materials. Polyester resin is particularly versatile. When combined with a metal powder, it gives the final cast an appearance of real metal. This technique is known as cold cast metal resin. Alternatively, the resin can be combined with a stone, marble, or slate dust, or any other inert powder. The final effect is similar to the texture and colour of the material from which the powder was obtained. Polyester resin can also be combined with translucent and opaque pigments to give a coloured finish. There is a wide variety of pigments available for use with polyester resin (see suppliers' list). When resin is combined with laminations of chopped strand mat (glass fibre), the sculpture is very strong and will stand up to outdoor weather conditions for a number of years.

Brake, *1966, Phillip King.*
*Fibreglass. Rowan Gallery, London*

# 3 Working with clay and plaster

Clay and plaster are the two most widely used materials for making sculpture. This chapter deals with some aspects of the preparation and use of these materials for modelling. The general techniques for plaster are also applicable when the material is used for making moulds and casts.

## Clay

Modelling clay should be firm enough to retain the form that the sculptor gives it, but at the same time it should yield enough to allow any further changes in its form that the sculptor may make. The following methods will return unworkable clay to a more malleable state.

### Wet clay
The remedy for clay that is too wet and therefore too sticky, is to spread it out on a board and leave it exposed to the air for an hour, or more if needed

### Hard clay
Clay that has become too hard can be softened if it is wrapped in damp rags and enclosed in a polythene bag for 24 hours.

### Reconstituting dry clay
When clay has dried out to such an extent that it cannot be softened with wet rags and sealed in polythene, it is best to leave it to dry out completely. When the clay has a dry, dusty appearance, break up the larger lumps to the size of golf balls, then put all the dried-out clay in a large plastic bowl or bin, cover with water, and leave for several days. The next stage is rather messy but worth doing if you want smooth clay. Pour off the surplus water, then put your hands into the bowl or bin and squeeze and knead the clay until it takes on a fairly smooth consistency. Remove all the clay from the bin and spread it out in a layer about 15 cm (6 in.) thick. The best surface on which to spread the clay is a dry slab of plaster of paris that measures at least 10 cm (4 in.) in thickness, 20 cm (8 in.) in width and 30 cm (12 in.) in length. Because the dry plaster slab is very porous, it quickly absorbs water from the clay and so prevents any additional mess caused by water running out of the clay. After a day or so the clay can be roughly shaped into balls (about 12 cm (5 in.) in diameter) and stored in airtight bins or plastic bags until required.

*Armature for life figure made from square section aluminium wire*

*Armature for modelling a clay bust*

*Log with slats nailed to it and string stapled to the slats to support clay. Note the 'butterflies' made from small strips of wood nailed together and suspended from the armature with string. This prevents large areas of clay from sagging*

*Sliding armature support and bolted bust peg*

# Armatures for clay

Even when perfectly constituted modelling clay is used, a large mass of it will still tend to sag under its own weight. Unless the sculpture is fairly small and compact, it is necessary to construct some sort of skeletal support. This is known as an *armature*. Sculptors use all sorts of devices to hold the particular shape of the sculpture. Empty tin cans, bits of wire and metal, wood blocks, sticks and string are some of the things used to support the clay. Apart from this 'Heath Robinson' approach, there are also purpose-made armatures that can be bought at sculpture suppliers. These can be used over and over again. Some types have movable parts which make them more versatile. For the sculptor building his own armature, the most useful material to buy is square section aluminium wire. This is soft enough to be bent into shape easily and has tended to replace the lead piping, traditionally used for the same purpose. Both can be bought from sculpture suppliers.

# Modelling in clay

The rough shape of the sculpture is first built up by pressing small pieces of clay on to the armature. Various tools can be used for shaping the model. Most sculptors have their preferences, but knives, steel spatulas, boxwood modelling tools, hacksaw blades, and sponges are all useful. The clay dries out quickly from the warmth of the hands or the air, if the studio is heated. To prevent this happening, the clay model should be sprayed with water. A thumb spray (available from sculpture suppliers) is ideal for this purpose. Alternatively, the water

*Clay sculpture modelled over log armature. Wood slats support the arms*

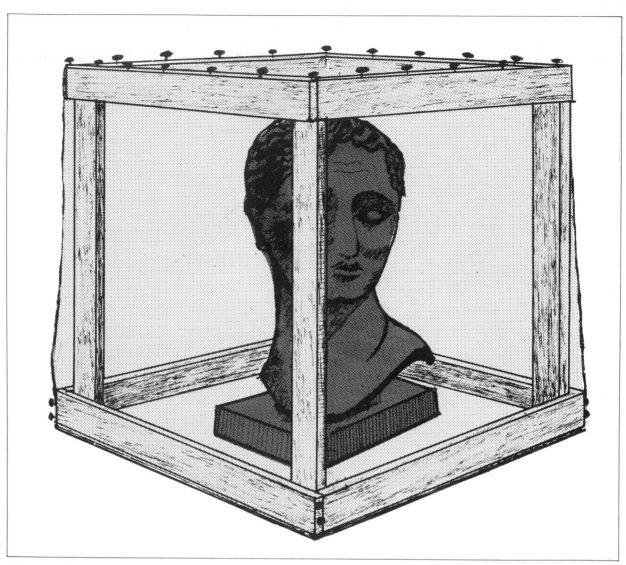

*A box made from wood battens and polythene.*
*The clay sculpture can be placed inside the box to keep it damp*
*between working sessions*

can be simply flicked on by hand. To avoid problems of drying out, never leave the clay model for long without covering it with wet rags and a sheet of polythene. At the end of the modelling session the sculpture should be wrapped completely in damp rags, covered with a sheet of polythene, and then string tied around the whole sculpture to prevent air circulating. If there is any delicate modelling, as there would be, for example, on a portrait head, some device must be constructed to prevent the rags coming into contact with the clay. A

quick method for portraits is to push a thin stick of wood into the clay sculpture so that it projects from the fore-head. This keeps the weight of the rags from pressing against the face. The stick can be removed just before casting and the hole it leaves patched up. A more elaborate method to protect the sculpture is to make a wood and polythene damp box for it to stand in. Wet rags are left in the bottom of the box so that the sculpture stands in a damp atmosphere, without anything touching it.

# Plaster

The best types of plaster for casting are dental, casting, or surgical plaster. These are most suitable because they harden fairly quickly (in about 10 minutes). When used for making moulds, these plasters take a good copy from the original model, and can be chipped away easily from the completed cast. Builder's plaster is unsuitable but as an economy measure it can be used to back up the first layer of the fine quality plaster. Plaster for casting can be obtained from the larger chemists, builders' merchants and art shops. It is generally sold in quantities of 7, 25 and 50 kg. Unless a small piece of work is being cast, it is more economical to buy the plaster in larger quantities (at least 25 kg). Plaster is usually packaged in a paper sack but it is much easier to use when it has been poured into a plastic or galvanized container, such as a dustbin. This reduces possible mess and helps to keep the plaster dry. It is essential that the plaster is not allowed to become damp. Plaster has a recommended shelf life of 3 months, but kept in an airtight container it can last up to 12 months before losing its setting properties. If there is any doubt that the plaster will set properly, it is inadvisable to use it for casting. A wise precaution is to test its setting properties beforehand by mixing up a small quantity.

## Mixing plaster

Mixing plaster is a messy business, so make sure that the room is well prepared. Cover the bench with a polythene sheet or newspaper. Sheets of newspaper or polythene on the floor will also help to prevent the plaster from being trodden in. To make strong plaster it is necessary to observe a few simple rules. It is most important to *add the plaster to the water*, never the water to the plaster. The water must be cold. Choose a suitably-sized mixing container such as a plastic bowl or bucket. As a rough guide to mixing plaster, the total volume that will be required is made up of 50 per cent water and 50 per cent plaster. In order that the stock of plaster remains dry, the storage bin containing it should be kept away from the source of water. Take the mixing bowl, containing the correct amount of water, to the plaster and with a dry hand, sprinkle handfuls of plaster into the water. Do not mix at this stage but continue to sift handfuls of plaster through the fingers into the water (this method helps to prevent lumps from forming) until the plaster becomes level with the surface of the water. Gently stir the mixture until it has the consistency of double cream. It is then ready for use. Plaster slowly changes from a liquid to a solid form in about 10 to 20 minutes, depending on the type of plaster. After it sets, it continues to harden and will require about 2 hours to reach its maximum strength. During part of this setting time a chemical reaction produces heat that makes the plaster feel warm.

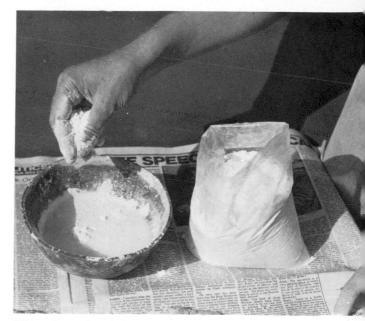

*Sifting plaster through the fingers*

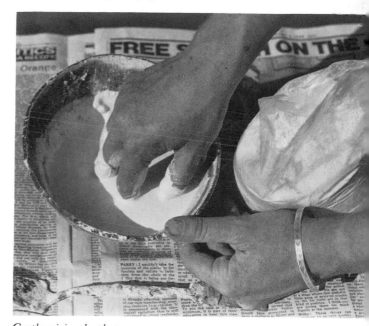

*Gently mixing the plaster*

Hands or anything covered in liquid plaster, should not be washed in the sink, otherwise the waste-pipe will quickly block. It is better to rinse the hands in a bowl of water. Several hours later, when the chemical action of the plaster is complete, the water may be drained carefully from the bowl, and the plaster sludge disposed of in the dustbin.

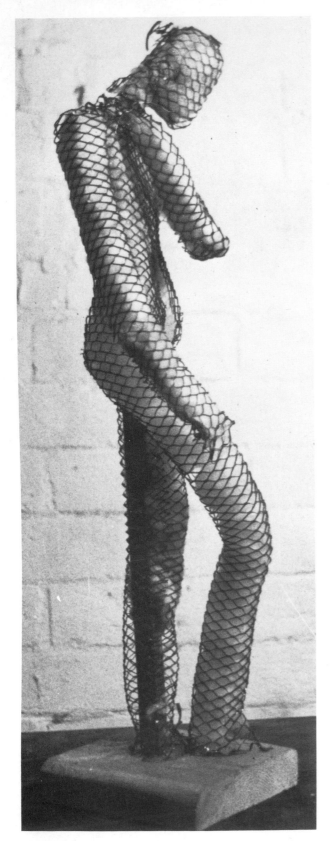

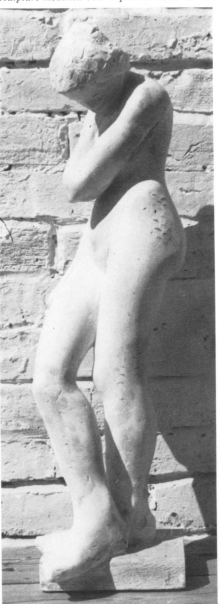

*Armature for a figure made from thin expanded metal. The metal was rolled into cylinder shapes, stuffed with newspaper and held together with twists of wire*

*Sculpture modelled over expanded metal armature*

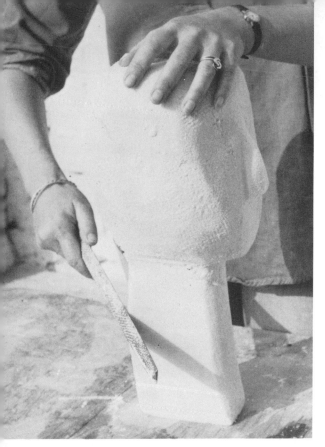

# Armatures for plaster

Armatures for plaster sculpture form an integral part of the sculpture and cannot be removed. This is quite different from an armature for a clay sculpture which can be reclaimed after casting by removing the clay from around it. For this reason, armatures for plaster sculpture are made by the sculptor from materials that are not too expensive. The type of ready-made armature that can be bought from a sculpture suppliers would not be suitable. Chicken wire, mild steel, thin expanded metal, galvanized wire, wood, aluminium wire, foamed plastic, thin binding wire, string and hessian are all suitable materials for making armatures. Generally the choice of material is determined by the shape of the intended sculpture. Armatures can be constructed in a variety of ways as shown in the photographs.

*Armature for a head made from expanded polyurethane*

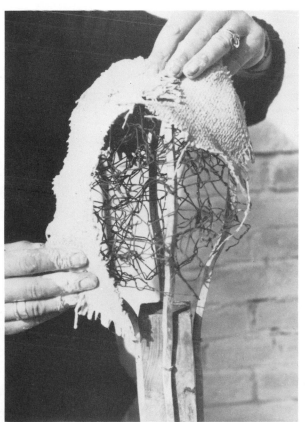

*Armature for a bust. This is made from a wood post and chicken wire. Scrim is soaked in plaster and placed over the armature to provide a firm base over which to model the plaster*

# Modelling in plaster

Plaster is used for modelling the original, as well as for making moulds and casts. Its properties are quite different from those of clay and the techniques for modelling take a little longer to master. Plaster is mixed in small quantities and built up over a framework or armature. The shape of the sculpture is formed by adding the plaster with a metal spatula and modelling it into position before it sets. When the plaster has begun to set but still has the consistency of cheese, it can be modelled, cut and scraped with precision, and when finally set hard it can be rasped and filed. Always keep the sculpture wet when adding more plaster as wet plaster will not adhere well to dry plaster.

When the plaster has dried out completely, after about a week in a warm place, it can be rubbed with glasspaper to achieve a very smooth finish.

This technique for making the original sculpture in plaster is preferred by some sculptors who dislike the soft, plastic quality of clay. The use of plaster as a medium combines the techniques of modelling and carving (ie adding and taking away).

*Tools for rasping plaster:* Surform *half round file,*
Surform *round file,* Surform *planer file, plaster rasps,*
*alabaster knife, craft knife, scratch tool, broken hacksaw blade*

# Preparation for casting with plaster

Careful preparation of the room or studio is always time well spent. Casting, which includes making moulds and pouring casts, is a messy procedure and when the hands are covered in plaster last minute preparations make even more mess. The following points are worth noting before casting.

1   Cover the floor with polythene or newspaper.
2   Cover the bench or table with polythene and newspaper.
3   Construct two or three boards behind the sculpture to prevent the plaster spreading. This is a useful device when the studio is not used specifically for sculpture. Alternatively you can pin a sheet of polythene behind the sculpture.
4   Place an empty cardboard box near the sink for disposing of hardened plaster from hands, bowls, etc.
5   Place a washing-up bowl or bucket of water on the draining board for rinsing plaster from hands. Remember that plaster will quickly block a waste pipe.
6   Leave an old towel or a supply of paper towels by the sink for drying hands.
7   Wear old clothes or a large smock. Old shoes or wellington boots are also advisable. Even a hat or scarf to protect the hair is a good idea as the plaster tends to splatter.

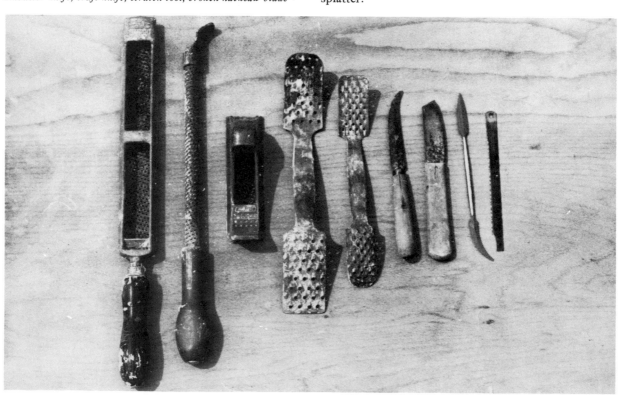

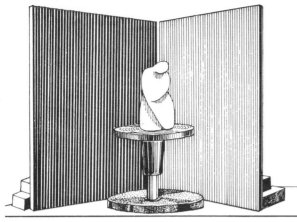

*A casting corner constructed from two boards*

The following tools and equipment will also be required

1   Two or three polythene bowls. The size depends on the sculpture. A bowl with a 1 litre capacity is useful. Washing-up bowls are ideal for most sculptures over about 20 cm (8 in.) high. It is essential that bowls are made of polythene as plaster does not adhere to it and when set can be cracked away easily. Rubber footballs cut in half, are also useful for mixing small quantities, as the plaster cracks away easily by flexing the bowl.

2   Brass shim (obtained from Tiranti, see suppliers' list, page 157). This is used for dividing up the mould into sections. Scissors or tin snips are used for cutting up the shim. A clay dividing wall may be used as an alternative to brass shim.

3   A sheet of newspaper for covering the half of the mould about to be cast. This prevents plaster splashing on it.

4   A small bowl or yogurt cup, a lump of clay about the size of a walnut, and a paint brush about 1 cm ($\frac{1}{2}$ in.) wide (for preparation of mould edge).

5   A lump of clay to make a clay wall around the base of the sculpture.

6   A knife or chisel with a rounded end for making registration holes (only required when using a clay wall).

7   A *Surform* file for cleaning mould seam.

8   A blue bag, powder paint or water based paint.

9   A skewer or thin metal spatula for digging out clay wedges.

10   Two old wood chisels and mallet for opening the mould.

*Equipment for casting*

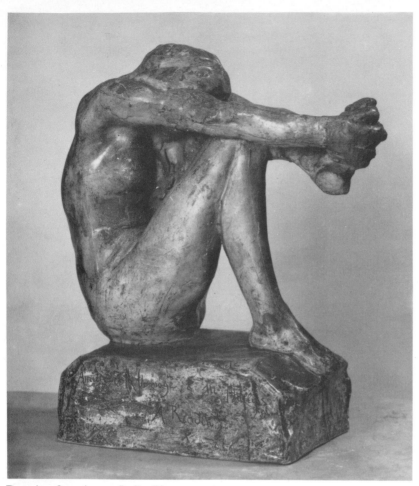

Despair, *1890, Auguste Rodin. Plaster*

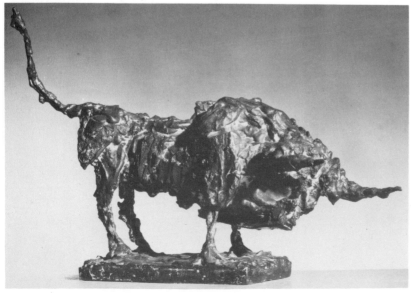

Bull    *Robert Clatworthy.*
*Treated plaster. Tate Gallery, London*

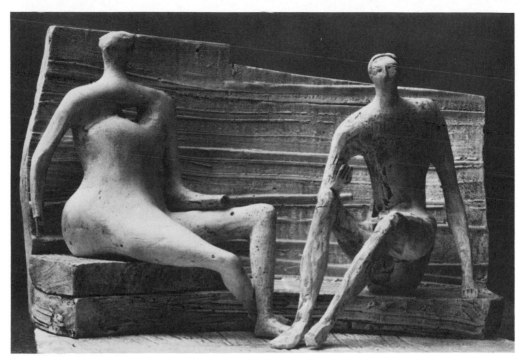

Two Seated Figures against Curved Wall, *1957, Henry Moore.*
*Preliminary plaster maquette for UNESCO Project*

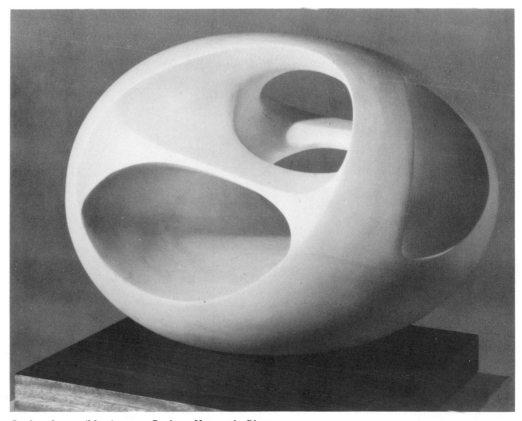

Oval sculpture (No 2), *1943, Barbara Hepworth. Plaster*

# 4 Simple techniques for casting reliefs

## Casting in plaster from impressions in clay

The easiest and most straightforward approach to casting is to pour mixed, liquid plaster directly onto a design made in clay or plasticine. When the plaster has set hard, the clay can be pulled away to reveal a reverse copy in the plaster of the original clay design. The technique for making simple casts that are small enough not to need reinforcement is as follows:

1 Cover the working area with newspaper and roll out a piece of clay, either on a sheet of polythene or a board. The clay can be rolled out with a rolling pin or a milk bottle, to a thickness of approximately 2 cm ($\frac{3}{4}$ in.).
2 Cut the clay slab to the required size and shape with a knife.
3 The design can be made on the clay by pressing hard objects into the surface. A variety of shapes, indentations and textures can be made with an assortment of objects such as keys, cogs, *Lego* bricks, hacksaw blades, *Surform* blades etc. The deeper they are pressed into the clay, the more the shapes will stand out when cast into plaster relief.

4 When the design is ready for casting, a wall of clay must be constructed around the edge of the clay slab to retain the liquid plaster while it sets. The clay wall is made by rolling out a piece of clay and cutting it into strips wide enough to project 3 cm ($1\frac{1}{4}$ in.) above the design.
5 Mix enough plaster in a polythene bowl to cover the clay panel to a depth of about 2 to 3 cm ($\frac{3}{4}$ to 1 in.). (See page 33 for mixing instructions.) Pour the plaster gently over the design. If the panel is to be hung on a wall, the ends of a wire loop should be immersed in the plaster before it sets (see page 50).
6 After about 30 minutes, when the plaster has hardened, the clay can be carefully pulled away from the plaster.
7 Gently clean the surface of the plaster with a small brush and water. To complete the relief, the plaster can be coloured, (see page 110 for ways of colouring plaster).

Four Reliefs, *Bernard Meadows.*
*Tate Gallery, London*

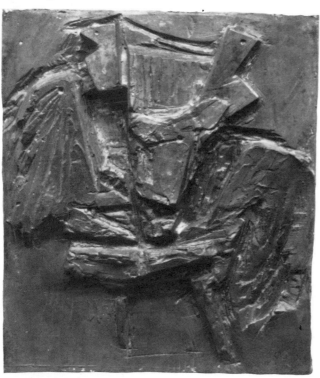 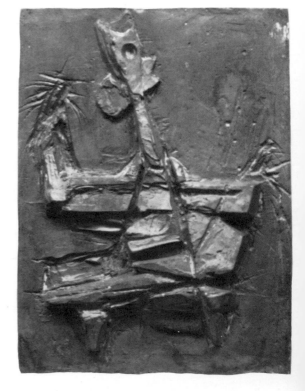

# Making a clay panel

A simple alternative method of casting a small panel is to put a layer of clay in the bottom of a washing up bowl or watertight cardboard box. The clay must be rolled out and cut to the size of the bowl or box. Impressions can be made in the clay before or after it is placed in the container.

The liquid plaster can then be poured into the bowl or box without having to build clay retaining walls.

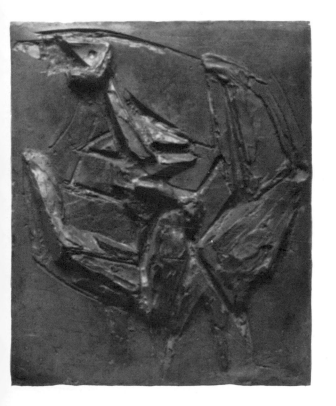

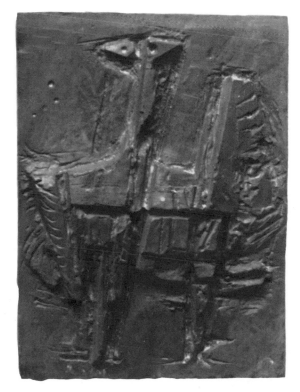

# Casting a large relief panel

The simple technique already described for making small plaster panels may also be used to make a relief panel on a larger scale. The process, although simple, is used by professional as well as by amateur sculptors and can result in effective and interesting work.

The panel was commissioned to hang above a modern fireplace. The size of the panel was 60 × 120 cm (24 × 48 in). It was cast in *Stolit* (see page 44) rather than plaster, as the mottled brown and rust colours which are a feature of this material were in keeping with the colours of the room where it was to be displayed.

Large relief panels with dimensions of 20 cm (8 in.) or more require reinforcement to prevent cracking. The method of fixing also requires some thought. Various types of reinforcement and fixings are described at the end of this chapter.

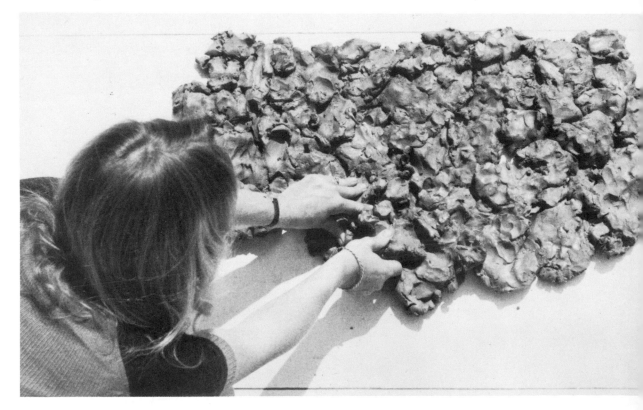

The outline of the relief is drawn onto a board. Lumps of clay are pressed onto the board. If the clay panel is to be stood up vertically for working on the design, it is necessary to knock a number of nails into the board before pressing on the clay. If the board has to support a heavy mass of clay, slats of wood nailed to the board is the safest method to hold the clay in position.

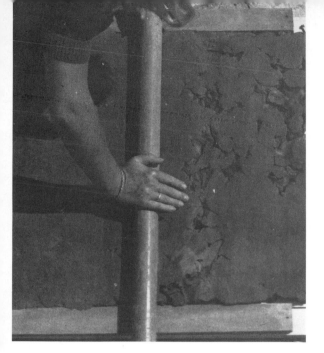

Roll the clay smooth with a piece of drain pipe. A wood batten is placed on each side of the clay so that both ends of the roller are supported and are level. This enables the clay to be rolled to an even thickness.

The design is made by pressing hard objects into the clay. The deeper the impression the higher the relief produced in the finished cast

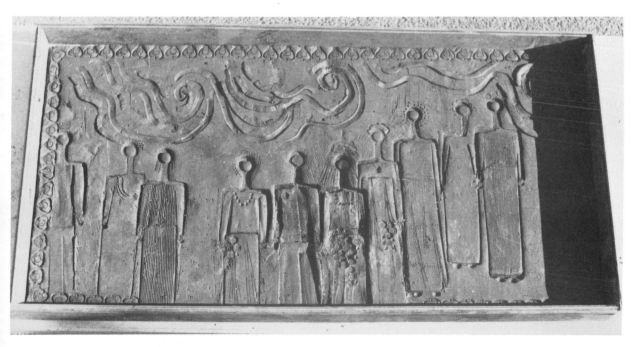

The panel is now ready for casting. Wooden shuttering has been cut to the size of the panel and tacked together in position. This had previously been painted with 2 coats of shellac to prevent the *Stolit* adhering. Any gaps between the wood and the panel should be filled with clay

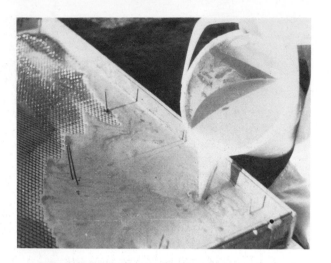

Prior to the stage shown in the photograph (left), a bucket of *Stolit* was mixed (as for plaster, see page 33) and poured as a first layer over the clay design. When this had begun to harden, after about 10 minutes, a sheet of expanded metal was placed over it. The expanded metal was cut to a size slightly smaller than the panel. Six bolts and three pieces of metal, bent to a hairpin shape, were attached to the expanded metal with binding wire. A further bucket of *Stolit* was mixed and poured over the expanded metal to sandwich it in the middle. More *Stolit* was then poured on to make the panel about 2 cm ($\frac{3}{4}$ in.) thick. It was left overnight to harden

The next day the shuttering was removed. The clay was freed from the board by standing it upright, and pouring water to break the suction. Rags were previously placed below the panel, so that it could be gently pushed downwards and away from the board without damage. The clay was removed from the panel. Finally, the completed panel was cleaned up by gently scrubbing the surface with a small, soft brush. The panel was then left to dry out

### Repairing the cast

After cleaning the cast relief, it may be found that there are pinholes in it or that parts of the surface are damaged. *Stolit* is an excellent material for making repairs as the colours blend in well. To make repairs, wet the damaged area of the relief, either fill the pinholes or model the damaged parts with *Stolit* and allow to set. When quite dry, rub the surface with glasspaper. *Stolit* is a grey powder and it forms a greyish mixture with the addition of water. It is not until it has hardened and dried that it turns to a golden colour due to oxidation of iron filings in the powder. It will therefore take about 12 hours for the areas that have been repaired to blend in with the original colour.

# Casting in plaster from impressions in sand

Instead of making the design in clay, an interesting alternative is to use sand. Plaster casts made from designs in sand have an interesting surface texture, which is caused by some of the sand adhering to the hardened plaster. Panels can be made using the techniques already described for casting from clay designs. The only difference is in the way the sand is prepared before making the design.

Sand for this type of casting can be of any type. Beach sand is ideal. Whichever type of sand is used, it must be sufficiently damp to hold the designs made in it. The sand needs to be either enclosed in a shallow box or in a deep-sided tray; or spread on a board with lengths of wood nailed together to make a rigid outer frame. The sand should be about 3 cm ($1\frac{1}{4}$ in.) in depth and well packed. It can be firmly compacted by banging the surface with a flat block of wood. The design can then be drawn in the sand with sticks, modelling tools, etc. When the design is complete, liquid plaster should be poured gently into one corner so that it flows over the design. When the plaster has set it can be gently lifted from the sand and all the loose particles brushed away. Reinforcement and fixings are made in the same way as in casting from clay (pages 49–51).

*Making designs in the sand by pressing into the surface with sticks and other objects*

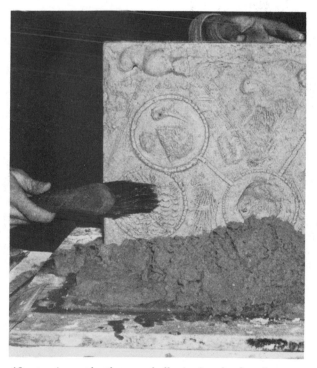

*After pouring on the plaster and allowing it to harden, the sand can be gently brushed away to reveal the design*

# Making a relief panel in cast stone

(model) (mould)  (cast)
clay → plaster → cast stone

Preceding sections dealt with the straightforward approach to casting, in which the resulting panel was a negative copy of the original design. In order to make a copy of the design that is identical to the original, it is necessary to add an extra stage. The following photographs show how a panel of this type can be made. It was first modelled in clay, then a plaster mould was made. (In the previous methods this constituted the cast.) The clay was removed and a mixture of white Portland cement and stone dust was packed into the mould in its place. The panel was made by children from Clanfield Junior School, Hampshire, to celebrate the Silver Jubilee of HM Queen Elizabeth II.

## Making the clay panel

*School children working on a clay relief*

## Cast stone

Cast stone is also known as *artificial* or *reconstituted stone* and is a useful material for making outdoor sculpture. The appearance of natural stone is achieved by mixing a natural stone dust with white Portland cement. White Portland cement is a fine-grade cement that can be obtained from builders' suppliers. It is a little more expensive than builders' cement. Like all cement, it should be stored in a dry place. Stone dusts are obtainable from most stone masons. Marble dust and marble chippings are alternatives that can be combined with white Portland cement. Most types of stone dust are relatively inexpensive. Other suitable materials that can be combined, are brick dust, silver sand, natural fine sand, vermiculite and pumice. (Cement 1:1 with any of these materials.) (For further details on cement see page 67.)

*Note*  Three-dimensional moulds may be filled in the same way as the relief mould used here. If the cast has to be hollow for lightness and strength, the mould should be lined with cast stone, so that the walls of the cast are about 2 cm ($\frac{3}{4}$ in.) in thickness. Reinforcement should be added and the cement mix compacted well. If it is difficult to prevent the cast stone from falling away from the vertical mould wall, the hollow should be filled with a core of expanded polyurethane, expanded polystyrene foam or sand. The core can be removed when the cast stone has hardened. (See chapter 6 for further details on casting with cement.)

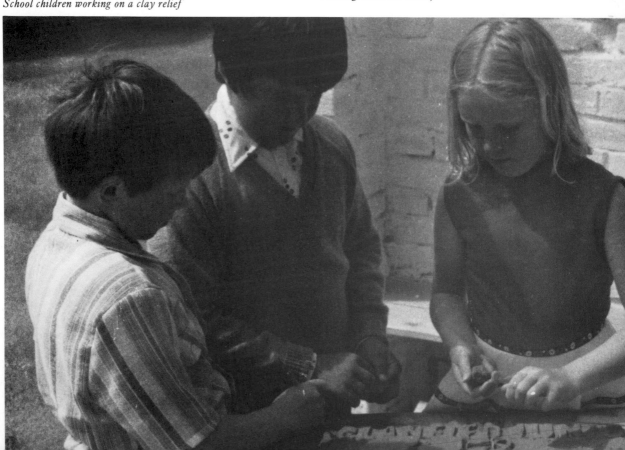

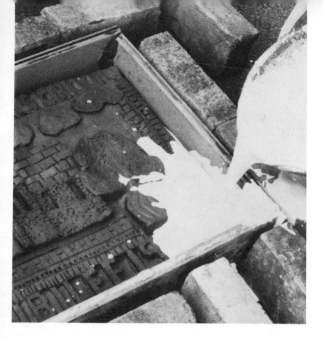

### Making the mould

Strips of wood kept in position with bricks, have been placed around the panel to make a mould box slightly larger than the panel. This will retain the liquid plaster when it is poured over the panel. The strips of wood should be given a coat of shellac to seal them. Rolls of clay are placed round the base of the wood shuttering to prevent the plaster from seeping out. The corners of the shuttering also need to be sealed with clay. The photograph shows the first layer of plaster being poured in. The mix should not be too thick, or it will not flow easily over the clay relief. The plaster should be poured in gently at the corner and allowed to flow across the relief so that it does not wash away the design

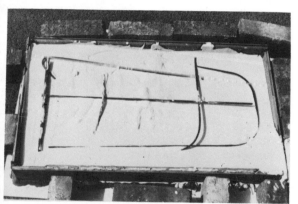

Once the first layer of plaster has hardened, lengths of metal are placed in position to reinforce the mould. These should be held in place with strips of scrim (see page 99). Further layers of plaster should then be poured on to a depth of about 2 cm ($\frac{3}{4}$ in.)

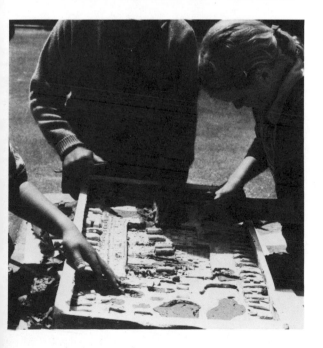

### Removing the clay

When the plaster mould has hardened it can be turned over and the clay removed. Wooden tools are suitable for this as they are less likely to damage the mould surface. If the clay film left by the clay is not disturbed no release agent is required. If the mould is cleaned with water a release agent must be applied (see page 63)

## Filling the mould

Portland stone dust (or any other type of stone dust or chippings) and Portland cement are mixed dry in equal quantities in a large bowl or shallow, wooden box. When thoroughly mixed, water should be added a little at a time and stirred in until the mixture binds together. A good test to determine whether enough water has been added, is to take a handful of the mix and squeeze – if it holds the shape of the hand, it is wet enough. The mixture can then be put in the mould and spread out to an even depth. The first layer of cast stone must be carefully tamped down, once it has been spread out in the mould. Tamping is done by banging the mixture with a short, blunt length of wood (about $15 \times 5$ cm ($6 \times 2$ in.) would be a suitable size). This compacts the mixture in the mould and removes pockets of trapped air. The first layer should then be covered with a damp cloth and allowed to harden slightly before adding reinforcement and fixings for hanging (see pages 49–51). When the reinforcement and fixings are in position, a further batch of stone dust and Portland cement should be mixed as described, and the mould completely filled and tamped. The surface of the mixture can be levelled by drawing a strip of wood across the mould. The mould should then be covered with a sheet of polythene and left for 24 hours to harden.

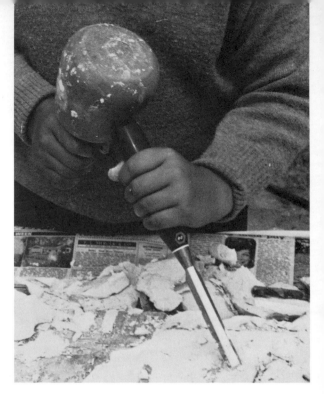

## Chipping away the mould

When the cement has hardened, the polythene may be removed, the mould turned over and placed on a table or bench. The plaster mould is then chipped away, using a wood chisel and wooden mallet. When most of the plaster has been removed, the remaining traces of plaster can be dug out with a sharp, pointed tool, such as a large darning needle. The surface of the mould can then be cleaned with a small scrubbing brush and water.

*The completed panel*

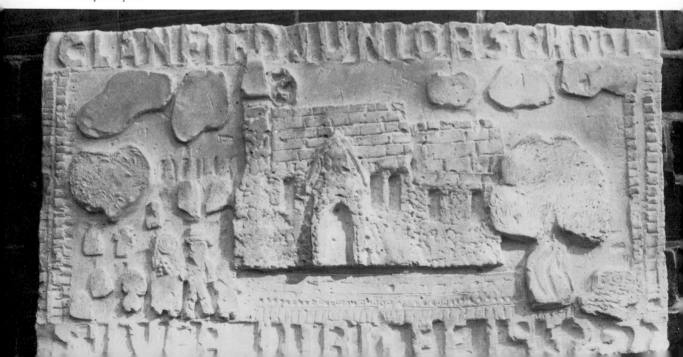

## Repairing defects in the cast

Ideally, pinholes caused by air bubbles or any similar defects, should be repaired before the cast has a chance to dry out (ie immediately after it has been scrubbed and cleaned). If the cast has been allowed to dry out it should be thoroughly soaked. A small amount of Portland cement with a sprinkling of stone dust should be bound together with enough water to form a paste. Damaged areas may be filled or built up using a metal spatula or knife. The panel should then be covered with a sheet of polythene and left for 24 hours. Finally, the panel can be left to dry out completely and the repaired surfaces can be made smooth by rubbing with medium and fine grades of glasspaper.

# Reinforcement for relief panels

Flat areas of plaster, *Stolit* or cement lack strength. Consequently, relief panels with dimensions of about 15 cm (6 in.) or more require some type of reinforcement. The usual method is to sandwich a layer of some stronger material, such as metal, inside the panel. This is done first by pouring a layer of the casting material directly onto the clay design. When this has hardened (it is important not to leave the first layer too long otherwise it will dry out and the layers may separate later), the layer of reinforcement is placed in position and more of the casting material is mixed and poured over the reinforcement, to the required thickness of the panel

There are various types of material used for reinforcement. The most common are scrim, glass fibre, metal rods, expanded metal and chicken wire. Scrim or glass fibre is generally used when the relief is plaster or *Stolit* and not more than about 30 cm (12 in.) long. It is cut to the shape of the panel or in wide strips and dipped in a mix of liquid plaster or *Stolit*. The scrim or glass fibre is then spread out flat over the first layer and when it begins to harden, more of the casting material is mixed and poured over the top.

A stronger method of reinforcement is to use mild steel bars or rods. These should be cut to the size of the panel but about 1 cm ($\frac{1}{2}$ in.) shorter so they do not protrude, and laid in a criss-cross fashion. When the rods are in place, they may be bound together where they cross with strips of scrim or glass fibre dipped in liquid plaster. This makes the framework more rigid and therefore stronger.

Another method of reinforcement is to use expanded metal sheets. This is a type of mesh which is generally available from larger builders' merchants. It should be cut slightly smaller than the dimensions of the panel. It is then sandwiched between layers of the casting material, as already described for the steel rods.

Where none of these types of reinforcement is available chicken wire can be used. This is quite satisfactory for reliefs that are not more than about 30 to 40 cm (12 to 16 in.) in size.

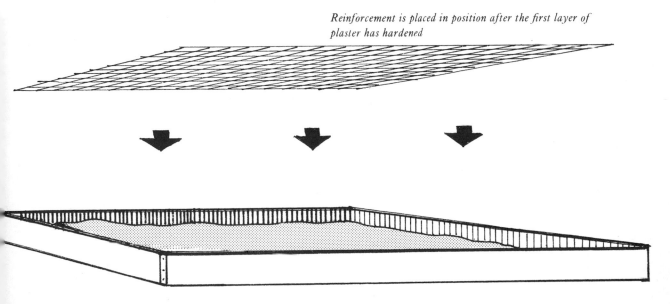

*Reinforcement is placed in position after the first layer of plaster has hardened*

# Fixings

The type of fixing used depends on the way in which the panel is to be displayed. Fixings must be put in position at the same stage as the reinforcement. If the panel is to be fixed to a wall or set in a wall, it is best to use bolts. These are attached to the reinforcement, which should be metal, by binding them together with a strong wire that will not corrode. The bolts must then be kept in a vertical position while layers of the casting material are built up to make the required depth. A large panel would require several bolts placed equidistantly

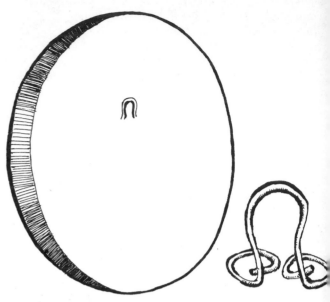

*A wire loop with ends curled round to prevent it pulling out of the plaster and the wire loop set in a plaster plaque.*
*This method is only suitable for small panels that do not require reinforcement*

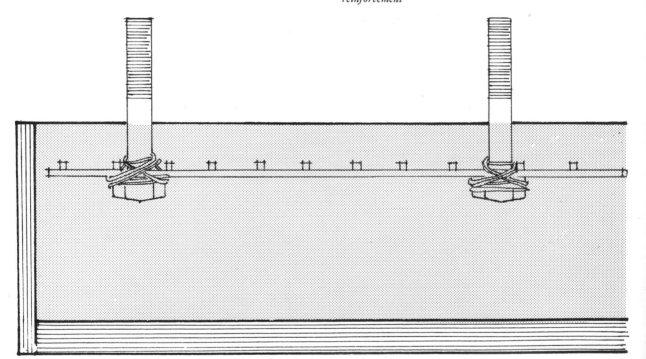

*Section through the relief, showing bolts embedded in the plaster*

Panels that are not too large or heavy for hanging from the wall, require wire loops. These must also be attached to the reinforcement for strength. If the reinforcement is metal the loops can be bound in position as already described for the bolts. If the reinforcement is scrim or glass fibre the ends of the loops should be poked behind the reinforcement before it has set. Strips of the same reinforcing material (glass fibre or scrim) should be dipped in liquid plaster or *Stolit* and placed over the ends of the loops to ensure that they will not pull out. More layers of the casting material are then poured over the reinforcement, as already described. Chains or picture wire can be attached to the wire loops and the panel suspended from a hook in the wall in the usual way.

*Section through the relief showing wire loops embedded in the plaster*

*Back of relief showing the position of the wire loops*

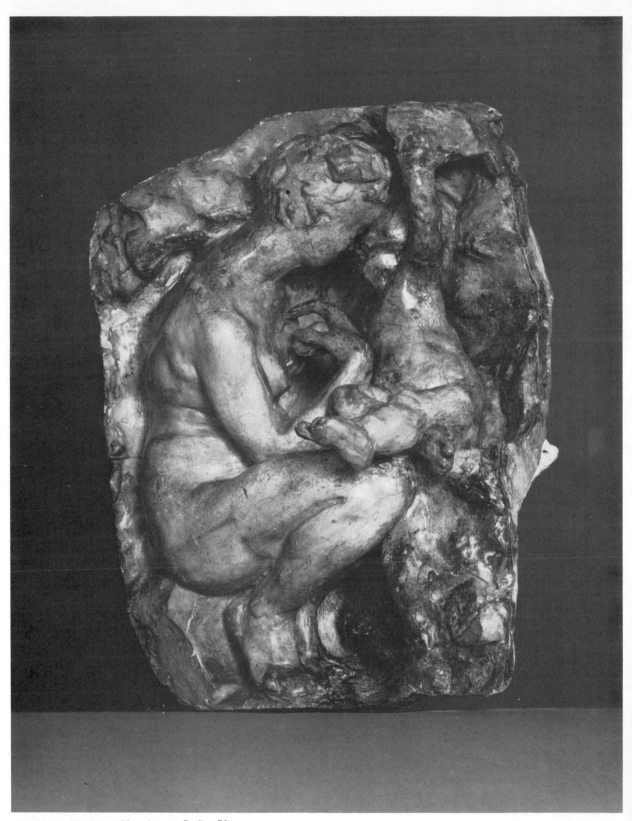

The Young Mother, *1885, Auguste Rodin. Plaster*

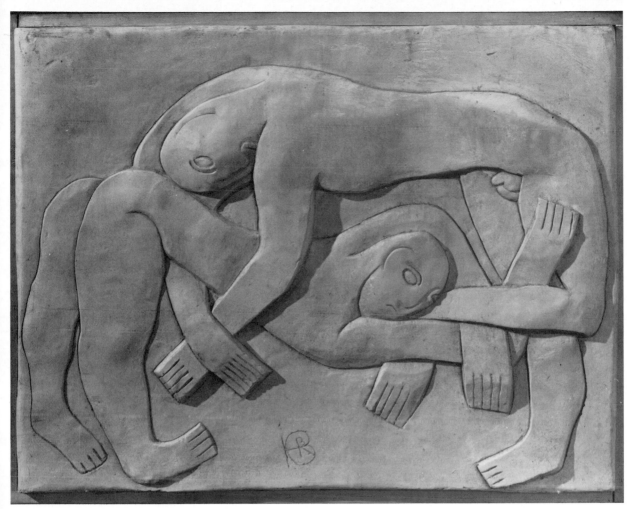

Wrestlers, *1914, Gaudier-Brzeska*.
*Plaster*

# 5  Mould preparation

There is a considerable amount of technical information to absorb when learning about the range of casting techniques and the application of a number of different casting materials. To make this information digestible, most of it has been kept within the context of a specific casting project. However, it is impossible to avoid tables and lists completely, as certain aspects of casting are clearer when presented this way. This chapter deals with the types of sculpture and moulds that a beginner would find suitable for a first attempt at casting; ways of sealing the original model before making the mould, mould dividers, the range of release agents and methods of assembling and filling the mould.

## The importance of shape

Modelling enables the sculptor to achieve a thinness and fragility of form that is not possible with carving. Rearing horses, dancers on points, and figures with limbs as thin as wire are all possible in clay provided there is a good armature inside the clay to support it. It is when the sculpture is ready for casting that the problems begin, because the final result can only be as good as the skill of the person doing the casting. It is a depressing experience to spend hours perfecting an ambitious sculpture only to lose it somewhere in the casting process. Good advice to the beginner is to practise casting on a sculpture that does not matter too much. Casting is a technical skill and like cooking, it becomes easier when one is more familiar with each stage and there is no need to refer frequently to a book. First attempts at casting should be with sculptures that are compact in shape. If the subject of the sculpture is to be, for example, a dancer, choose a pose where the limbs and the torso form one continuous shape. This is important because any thin, elongated projections can easily break off when the mould is removed.

*For a first attempt at casting, choose a subject that is fairly compact in shape*

*Avoid sculpture with thin projections*

## Selecting the mould material

The table below lists the various materials that can be used for the model and the appropriate mould-making materials. Combinations of model and mould-making materials that are *not* recommended or are unsuitable, are indicated with an X.

| Model making material | Mould making material | | | | |
|---|---|---|---|---|---|
| | plaster | hot melt com-pound | cold cure sili-cone rubber | latex | poly-ester resin and glass fibre |
| clay | √ | √ | √ | √ | X* |
| plaster | √ | √ | √ | √ | √ |
| wax | √ | X | √ | X | √ |
| plasticine | √ | X | √ | X | √ |
| expanded poly-urethane and poly-styrene | √ | X | √ | X | √ |
| poly-ester resin and glass fibre | √ | √ | √ | √ | √ |

* Occasionally clay can be dried out successfully without cracking and then sealed with *G4* varnish (for details of *G4*, see page 110).

# Sealing the model before making the mould

Most sculptures, unless they are made from clay, require some treatment to prevent the mould adhering to them. This should be done before the mould dividers are put in position. The following table shows the best methods for sealing sculpture.

| Model material | Mould material | | | | |
| --- | --- | --- | --- | --- | --- |
| | plaster | hot melt compounds | cold cure silicone rubber | latex | polyester resin and glass fibre |
| plaster | seal with shellac then wax *or* use soft soap | seal with G4 varnish *or* use water wet (ie soaked in water) | none* | none | seal with two thin coats of shellac then wax then PVA *or* seal with Scopas parting agent |
| plastic stone *Stolit* | seal with shellac then wax *or* seal with G4 varnish* then wax | seal with G4 varnish *or* use water wet | seal with shellac then apply 5% Vaseline in white spirit solution (for application see *) | none | seal with shellac then wax then PVA *or* seal with G4 varnish then wax then PVA |
| wood *untreated* | seal with shellac then wax | seal with G4 varnish *or* use water wet | none | none | wax then PVA |
| wood *polished* | seal with shellac then wax | seal with G4 varnish *or* remove polish then use water wet | 5% Vaseline in white spirit solution (for application see *) | none | wax then PVA |
| concrete *or* *Ciment fondu* | seal with shellac then wax | use water wet *or* seal with G4 varnish | none* | none | seal with polyurethane varnish then wax then PVA *or* seal with G4 varnish then wax then PVA |

| Model material | Mould material | | | | |
|---|---|---|---|---|---|
| | plaster | hot melt compounds | cold cure silicone rubber | latex | polyester resin and glass fibre |
| expanded polyurethane *and* expanded polystyrene | seal with Vaseline *or* use untreated and burn out of mould | unsuitable | none* | none | seal expanded polyurethane with G4 varnish then wax then PVA *and* seal expanded polystyrene with shellac then wax then PVA |
| polyester resin and glass fibre | use soft soap *or* Vaseline | none | none* | none | wax then PVA |
| wax | no treatment necessary – melt out of mould | unsuitable | none | unsuitable | no treatment necessary |
| skin *casts from life figure* | Vaseline | unsuitable | unsuitable | unsuitable | unsuitable |
| plasticine | seal with shellac | unsuitable | seal with shellac then apply 5% Vaseline in white spirit solution (for application see *) | unsuitable | seal with G4 varnish then wax then PVA |

* Silicone rubber moulds do not generally require sealing but for easy release the following procedure is a wise precaution. Paint the sculpture with two coats of shellac. The varnished surface should be allowed to dry and then treated with a solution of 5 per cent *Vaseline* in white spirit. Brush or wipe on and then rub off, leaving just a trace.

# One piece moulds

There are some shapes that can be cast in a one piece mould. This type of mould is only suitable for rather broad, shallow sculpture, like the panel described on page 46.

*Note* A plaster mould made around a rigid material, such as stone or cement, will become locked in position unless the sculpture is a simple shape and has no undercuts. It may be advisable, instead, to use a flexible mould, as this can be pulled away from the rigid sculpture without damage. If it is thought necessary to make a plaster mould from a sculpture in stone, wood, concrete, or plaster, a piece mould will usually have to be constructed (see page 146).

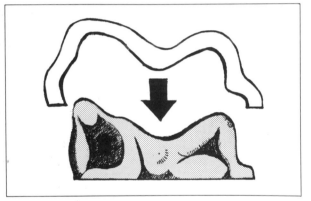

*The shape made by the reclining pose shown here could be cast using a one piece mould. When the mould has set, the board is removed from under the sculpture. The mould can then be inverted and the sculpture removed*

# Mould dividers

Sculptures are generally too complicated to be cast using a one piece mould. In most cases the mould will need to be made in more than one piece to facilitate the removal of the model. This is done with mould dividers.

Mould dividers are generally made from thin sheets of brass, clay or plasticine. They should be positioned so that the seamlines on the cast are as inconspicuous as possible. For example, on a portrait head, the mould divider should be constructed so that it runs in front of or behind the ears. The following section shows the method of constructing mould dividers from clay, brass (shim), and plasticine.

### Clay
Clay bands are made by pressing or rolling a piece of clay flat and then cutting it into strips. The clay strips are then pressed onto the sculpture surface, making sure that they adhere firmly. The clay sculpture should not be too wet otherwise it will be damaged when the clay strips are pressed onto it. Clay buttresses must then be constructed behind the clay wall for support. Clay bands are not left in position between the mould pieces. It is necessary to cast one section of the mould at a time. When one part of the mould is complete the clay bands between it and the next piece must be removed.

There are three procedures to remember:

1  *Keyways* (registration holes) must be cut. These are shallow, round holes that are made in the mould edge. A round ended knife rotated in the plaster will cut a neat hole. When the next part of the mould is made, the plaster which fills the keyway will form a rounded projection exactly filling the hole and acting as a key to ensure that the two halves of the mould match.
2  The mould edge should be painted with clay slip to prevent it adhering to the next part of the mould.

*The mould for this head must be divided in half*

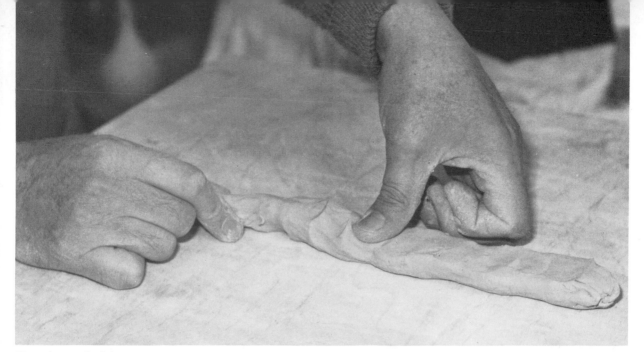

*Flattening a roll of clay*

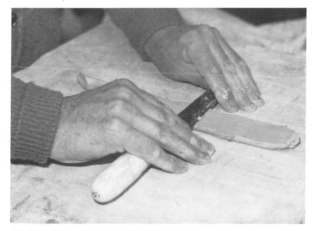

*Making the surface smooth with a knife*

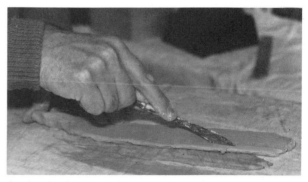

*Cutting the clay into strips*

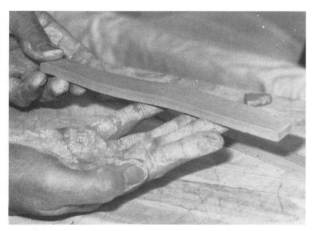

*The clay strip ready to be cut up and put in position around the model*

*The clay band fitted round the head with buttresses to support it*

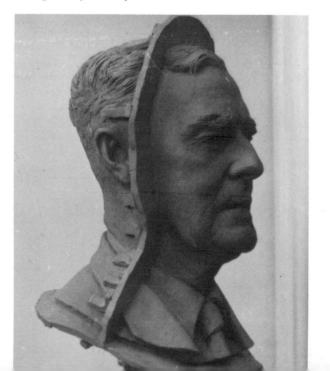

**3** A clay wedge should be placed against the mould edge. The function of this is to leave a hole in the seam between the mould pieces. This enables water to be poured around the clay sculpture encased in the plaster. When this happens the clay expands slightly, which helps to open the mould. The holes are also used for inserting chisels or wooden wedges to prise the mould sections apart.

Although learning to make clay bands takes a little more time and experience than using brass shim, some sculptors consider it worthwhile. This is because the clay band is very smooth and so makes a flat mould edge. Also, as the bands are removed, each mould edge is cast directly against the next one, which results in mould pieces that fit together very tightly. The advantage of this is that the casts made from the mould have much neater seams. This eliminates some of the work involved in cleaning up the cast.

### Brass fencing (shim)

Shim is a brass fencing used for dividing plaster moulds. Shim can only be used on sculpture made from soft, malleable materials such as clay or plasticine, as it must be pushed into the sculpture to keep it upright. Shim is generally sold as a roll of sheet metal about 15 cm (6 in.) wide. It is sold by weight and half a kilogram is approximately 4 metres long (1 lb is 12 ft long). Shim is fairly expensive but with care it can be used a number of times. It should be cut with strong scissors or tin snips into strips about 4 cm high and 6 cm long (1½ × 2 in.). The lines for the divisions around the sculpture, once decided upon, should be drawn lightly onto the sculpture with a pointed tool. The pieces of shim are then pushed into the sculpture to a depth of about 5 mm (¼ in.). The strips should overlap slightly, with no jagged edges or corners sticking out, as these would prevent easy and quick cleaning of the seams. The outer edge of the shim should follow the contours of the sculpture. At one or two points along the seam a piece of shim should be bent to form a rounded (or V-shaped) groove. This forms a male and female locating shape in the adjoining sections of the mould which acts rather like a press stud and ensures that the mould pieces fit together accurately. They are called the *registration keys*. Pieces of shim that will not remain flush with the line of shim, may be brought together with paper clips or clips made from shim. Clips of shim are made by cutting lengths of about 5 × 1 cm (2 × ¼ in.). These are folded tightly and slipped over the two edges to keep them together. Several clay wedges should be positioned against the brass shim. Through the holes made by these wedges, water can be poured into the completed mould to open it. The shim is left in position and all the sections of the mould are built up in plaster at the same stage. Plaster should not be allowed to cover up the shim fencing so that it is buried. To prevent this happening, after each new application

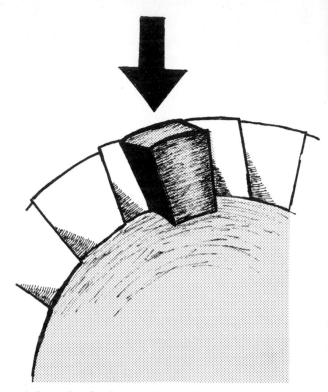

*A clay wedge placed against the shim fence*

of plaster, the top of the brass fencing should be scraped with a knife. When the plaster mould is finished, the top of the brass fencing should show as a thin brass line. The top of the clay wedges should also show.

### Plasticine

Plasticine is generally used with polyester resin and glass fibre moulds. Polyester resins do not harden properly in contact with clay or any other materials that contain moisture. Plasticine may also be used as a mould dividing wall on sculpture made from hard, dry materials such as stone, plaster and wood.

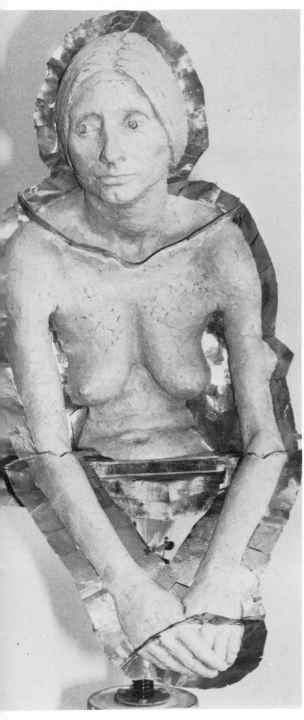

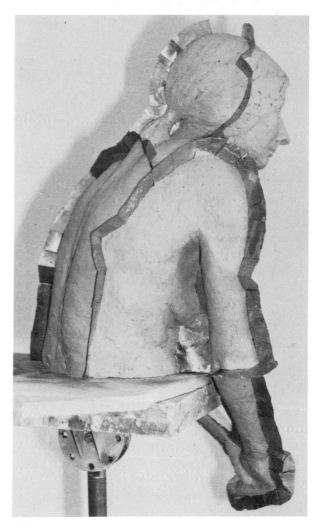

*Side view of the same sculpture*

*Front view of a sculpture, showing the position of the mould dividers (by a student at Southampton College of Art). The V-shaped shims that form the registration keys are clearly visible*

61

## Dividing the mould

With most sculptural shapes there are no fixed positions for placing the divisions. The important thing to remember is that it should be possible to open the mould so that the sculpture inside can be easily removed. However careful one is in planning where to divide the mould pieces, mistakes can happen. Often these are not discovered until the mould has been made and the pieces of the mould are being prised apart to remove the original sculpture. It may then be found that a small opening is the only access to some important part of the sculpture which is otherwise completely encased. Sometimes even a small opening can be used to remove a clay original. Thin wires or knitting needles pushed down through the hole can be used to hook out the clay, but this is not always possible. Another, more drastic, solution is to decide on a line that will provide the necessary access, and then to cut the section into two pieces with a hacksaw.

Some sculptors plan the mould divisions so that a cap or lid is made for every part of the mould that needs an access point. When the mould is complete these lids are prised off, and the clay is pulled out of that part of the sculpture.

## Reinforcing plaster moulds

Small moulds may be reinforced with pieces of scrim (loosely woven jute) or glass fibre soaked in plaster. Moulds with dimensions of about 15 cm (6 in.) or more, require stronger reinforcement. Lengths of mild steel are generally used for this purpose. This is cheaper when obtained from a scrap merchant. It is also more suitable for reinforcement when it is slightly rusty, as it keys better with the plaster. Any loose scale on the iron should be removed with a wire brush. Oil or grease should also be removed. As it is usually necessary to bend the irons, they should have a gauge of about 6 mm ($\frac{1}{4}$ in.). Reinforcing irons should be placed in position on the mould before the final coat of plaster is applied. The lengths should be cut and bent so that they strengthen any part of the mould that is structurally weak. The irons are placed in position and then secured with strips of scrim soaked in plaster. Make sure that the irons do not lie across any mould seams as this would prevent the mould from opening.

Larger moulds should also be strengthened on the outside so as to prevent any whip or cracking when the mould is handled. Lengths of wood or metal are used for this purpose. They are attached to the mould with strips of scrim soaked in plaster. This should be done as soon as the mould is completed, otherwise the mould will dry out and the scrim will not adhere.

*A mould divided using a system of caps to give access to the inside of the mould*

# Opening the mould

To open the plaster mould, the clay wedges should be dug out with a thin tool such as a metal spatula. The mould should then be submerged in a large sink or tank. Alternatively, water can be poured into the holes made by the clay wedges. The action of the water breaks the adhesion and expands the clay inside the mould, forcing the mould sections slightly apart. Chisels or wood wedges can then be placed in the holes and the mould gently prised apart.

Glass fibre moulds can be opened in a similar way. The only difference is that the water seeps in between the mould sections so it is not necessary to use plasticine or clay wedges.

# Release agents

Most rigid moulds must be treated with a release agent before they are filled to make a cast. There are many different types of release agents (also referred to as *separators* and *parting agents*) but their function is always the same. They are applied to the mould surface in order to seal the pores and therefore prevent the cast from adhering to the mould. The following are the most common.

### Clay wash
This is the easiest of all release agents to use. Dissolve a small lump of dry clay in water and paint the clay water onto the mould surface with a soft brush. A clay wash is most suitable for plaster moulds that are to be filled with concrete or *ciment fondu*. It is important that the plaster mould is very wet. If it has been allowed to dry out, it should be immersed in clean water and thoroughly soaked before application of the clay wash. The clay wash tends to be retained on the cast in the form of a whitish bloom. This is removed with a wire brush and water as soon as the cast has come out of the mould.

### Clay film
When a clay sculpture has been removed from the plaster mould, a fine film of clay is left on the mould surface. This makes an ideal release agent because it is fine and the detail is not blurred, as it can be with thicker release agents. Do not clean the mould with water but simply dab the mould surface with a small lump of clay, to pick up the small pieces that remain after the bulk of the clay sculpture has been removed. Make sure that the mould is saturated with water before filling with the casting material. Like the clay wash, this type of release agent is most suitable for concrete and *ciment fondu*.

### Wax polish and polyvinyl alcohol (PVA)
This combination of release agents is used on glass fibre or plaster moulds in preparation for glass fibre casts. Any good wax polish may be used, providing it is silicone-free. Silicone will cause surface blemishes on the glass fibre casts. The mould should be coated with wax polish and when dry, buffed with a soft cloth to a high gloss finish. A thin coating of polyvinyl alcohol (PVA) is then applied with a fine sponge. Avoid using a brush, as this will cause tramlines which will subsequently be reproduced on the surface of the cast.

### Linseed oil
This is sometimes used as a release agent for plaster moulds when using cold casting techniques (ie polyester resin, glass fibre and metal filler). Two applications of boiled linseed oil should be applied. Enough time should be allowed between each application for the oil to become fully absorbed. A thin coat of PVA is then applied as described in the previous section.

### Scopas parting agent
This is a pink, water soluble parting agent used for plaster moulds that are to be filled with polyester resin and glass fibre. The parting agent is mainly used for sculpture that has detail that would become clogged with the wax polish type of release agent. One coat of *Scopas* parting agent should be painted onto the mould and left to dry in a warm atmosphere. The parting agent should not be allowed to form pools in the hollows of the mould. If this happens it will have a tendency to lift when the resin is applied. Lifting of the parting agent will also occur if the resin is allowed to form in pools. The mould should be filled as soon as the parting agent is dry. As the parting agent is water soluble, the mould may be soaked in water once the resin has cured completely. The parting agent will then have a slimy consistency, which facilitates the removal of the cast. (*Scopas* parting agent is available from Tiranti.)

### Oil
Oil may be used on plaster moulds as a release agent for plaster, concrete and *ciment fondu*. The oil must be of a light grade such as machine oil and it is important that it is applied in a fine film. Too much oil in the mould may react with the casting material and prevent it hardening properly. Pour a few drops of oil in the palm of the hand and, dabbing a brush lightly in the oil, apply sparingly over the mould surface.

## Soft soap

Any pure soap may be used as a release agent for plaster moulds. Green soap, available from chemists, is very good. To prepare the soap it should be diluted or boiled in water, to form an emulsion. This should be applied to the mould surface and brushed to form a lather. The lather should be left for about 15 minutes to become absorbed and then washed away with cold water. A second application of the soap should be applied in the same way. A trace of light oil may then be applied to ensure a good release. The mould should be well soaked in clean water before filling. Soft soap is mainly used for separating casts in plaster, plastic stone, concrete or *ciment fondu* from plaster moulds.

## Shellac and wax

Shellac must always be diluted with pure alcohol or methylated spirits when used as a release agent. If it is too thick, it will blur the detail of the casting. Apply the shellac in 2 or 3 coats, allowing time for each coat to dry. Finally, rub liquid wax (liquid wax furniture polish may be used) over the mould surface with a soft cloth. This release agent combination may be used when the plaster mould has dried out completely. As an alternative to liquid wax, a thin application of machine oil may be used (unsuitable for glass fibre casts). These release agents are useful when the discolouration and bloom that is left by a clay wash has to be avoided. If concrete or *ciment fondu* is to be used, soak the mould thoroughly before filling. If the plaster mould is being prepared for a glass fibre cast, it must be completely dry.

*Note* Flexible moulds made of cold cure silicone rubber, hot melt compounds and latex rubber do not usually require a release agent.

The table below shows the various release agents suitable for a particular type of mould, and the casting material that may be used in conjunction with the release agents.

| Mould material | Release agents | Cast material |
|---|---|---|
| plaster | clay wash<br>clay film<br>shellac and oil<br>shellac and wax<br>oil<br>soft soap and oil | concrete<br>cast stone<br>*ciment fondu* |
| | soft soap and oil<br>shellac and wax<br>oil | plaster<br>plastic stone |
| | wax and PVA<br>*Scopas* parting agent<br>boiled linseed oil | polyester resin and glass fibre |
| polyester resin and glass fibre | wax and PVA | polyester resin and glass fibre |
| | oil or wax | concrete<br>*ciment fondu* |
| flexible materials<br>hot melt compounds<br>cold cure silicone rubber<br>latex | none | plaster<br>plastic stone<br>*ciment fondu*<br>concrete<br>cast stone<br>polyester resin and glass fibre |

# Assembling the mould

Once the mould has been made and the original sculpture removed, it is important that the mould does not warp. This can be avoided if the mould pieces when not being used are kept assembled and tied tightly together. A simple two-piece mould is generally quite straightforward to assemble. The parts of the mould are fitted together so that the registration points are correctly aligned and then tied with strong string, such as sisal.

In order to increase the tension on the string once it has been tied, small wooden wedges can be tapped into position under the string. Old nylon tights are quite a good way of tying plaster moulds, as they are strong and do not slip. Strong wire is another way of tying moulds, however it is usually advisable to use the wire double, to prevent it from breaking when twisted. To tighten the wire around the sculpture, twist the ends together with a pair of pliers to make a tourniquet. The string or wire may be prevented from slipping down on a tapering mould by cutting small slots or grooves in the plaster.

Sections of the mould may be clamped with a type of 'metal dog'. This can be made by bending the ends of a length of mild steel at right angles. It can then be tapped into position over the mould pieces (see page 120). A similar device, called a *joiner's dog clamp*, can be bought from tool suppliers. Moulds made from a number of pieces are often too complicated to tie. Each piece should then be put in position in turn and joined with straps of scrim or chopped strand mat (glass fibre) dipped in liquid plaster.

# Filling the mould

This generally takes place at the same time as assembling the mould. The method of filling the mould depends entirely on its shape and structure, so common sense must be the main guide. For example, parts of the mould that become inaccessible when the mould is assembled must be filled beforehand. Very often the assembling of a multi-piece mould is a combination of filling inaccessible parts before assembling them, fitting them in position secured with plaster and scrim, and then filling the main parts that become accessible as the mould is put together. Moulds that are filled with a liquid material that solidifies (such as plaster), are usually quite straightforward. The mould can be assembled, the seam filled with plaster, and the casting material poured in through a pre-made pouring hole. The mould may have to be supported while it is being filled. This can be done by standing it in a bucket or box with packing sand around it. Any parts of the cast that are structurally weak will require reinforcing with lengths of mild steel, or pieces of scrim or glass fibre dipped in plaster. More specific approaches to filling the different types of moulds are dealt with later.

The table below summarizes the various combinations of mould-filling materials (cast materials).

| Mould material | Cast material | | |
|---|---|---|---|
| | **plaster** *or* **plastic stone** | **concrete** *or ciment fondu* | **polyester resin and glass fibre** |
| plaster | √ | √ | √ |
| hot melt compound | √ | √ | √ |
| cold cure silicone rubber | √ | √ | √ |
| latex | √ | √ | √ *limited life* |
| polyester resin and glass fibre | √ | √ | √ |

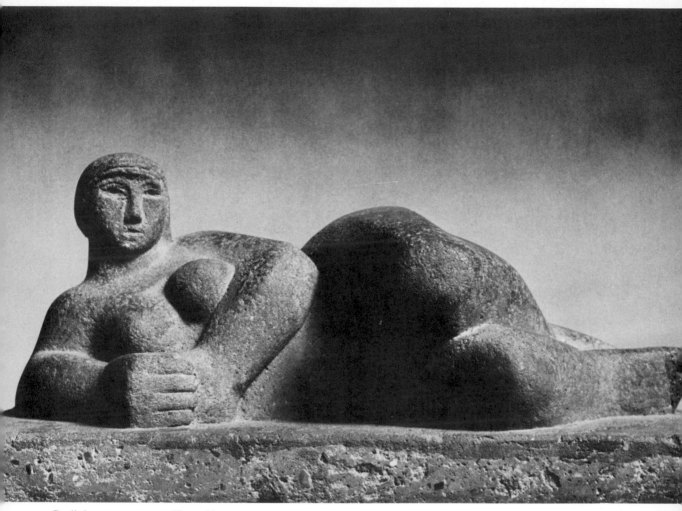

Reclining woman, *1927, Henry Moore.*
*Cast concrete*

# 6 Casting in concrete and ciment fondu

Before the introduction of glass fibre, concrete was one of the principle materials used for cast sculpture. Its cheapness, durability and ability to withstand weather conditions, have made it a common material for outdoor sculpture. The range of colours that concrete can be given (by the use of coloured cement or coloured aggregates) adds a greater versatility to the medium. Its natural stone-like quality enables outdoor or garden sculpture to blend in well with the landscape. The effect of the weather on the material often softens and enhances the appearance of the sculpture.

Concrete is made by mixing cement and an aggregate with water. The mix is then allowed to set. There are basically two types of cement, Portland cement and high alumina cement (*ciment fondu*). As the appearance of sculpture cast in these two kinds of cement is different, they are treated as separate materials in this chapter. *Portland cement* is made from the raw material calcium aluminium silicate, and derives its name from Portland stone which it resembles when mixed as concrete. *High alumina cement* is made from the raw material, alumina. Both these cements are manufactured by heating the raw material to drive out the water and form a clinker. This is ground to a powder, in which form it is then sold. When water is added to the powder, a chemical reaction, called *hydration*, is started. During the course of this reaction, water is absorbed by the cement and the liquid mix changes to a solid. It is this chemical reaction that makes concrete an excellent casting material. A mixture of cement and water has no tensile strength but adding an aggregate to the mix gives the concrete a much greater strength.

## Materials

Concrete is made by mixing cement, sand and stones with water. The sand is sometimes described as *fine aggregate*, the stones as *coarse aggregate*. There are various ways of obtaining concrete; buying the materials and mixing them yourself; buying dry-mix materials and adding the water, and buying ready-mixed concrete for casting large sculpture. If you are mixing the concrete yourself, the cement can be bought from builders' merchants. It is sold in bags of about 50 kilos in weight. The aggregates can also be bought from builders' merchants. In some districts, where there are local gravel pits or quarries, supplies of aggregates can often be obtained direct.

Ordinary Portland cement is grey in colour. Other colours can be introduced into concrete by using coloured cements, of which there is a wide range. Alternatively, white cement can be used and combined with a coloured aggregate. All cement should be dry, fresh, and free from lumps that cannot be broken easily in the fingers. If the cement has to be stored before use, it must be kept dry and should be kept under cover and clear of walls and floors.

Sharp sand (ie *concrete sand*) should be used for making concrete, whereas soft sand (ie *builders sand*) should be used for *ciment fondu*, and for sand and cement mixes. It is most important, however, that the sand is clean. Coarse aggregates can be either of gravel or of crushed stone, varying in size between 20 mm ($\frac{3}{4}$ in.) and 5 mm ($\frac{3}{16}$ in.). For thin sculptures that are less than 50 mm (2 in.) thick, the aggregate used in the concrete mix should comprise chippings not more than 10 mm ($\frac{3}{8}$ in.) in size.

## Mixes

For most concrete sculpture, one of the following mixes may be used.

### Ordinary concrete mix
*parts by volume*
1 part cement
2 parts sand
3 parts coarse aggregate

### Sand and cement mix
*parts by volume*
1 part cement
3 parts sand

*Note*   The colour of the cast has a slightly lighter shade than that of the sand.

### Cast stone* mix
*parts by volume*
1 part cement
1 part stone dust

* Cast stone is also known as reconstituted stone.

### Ciment fondu
*Ciment fondu* is a cement that is often used for cast sculpture. It is a high alumina cement and sculpture made in this material, like Portland cement, will withstand out-

door conditions. It is widely used in schools and colleges because it is cheap, easy to use and gives a pleasing metallic appearance to the cast. Its short setting time is another advantage to the sculptor. The cement has a black colour and must be combined with either sand or glass fibre for strength. To give a smooth surface to the cast, a mixture of *ciment fondu* and water is first painted on the inside of the mould. This layer is then backed up either with a cement and sand mix or with cement and glass fibre laminations. The completed cast can be buffed to a metallic shine with wire brushes.

**Ciment fondu mix**
*parts by volume*
1 part *ciment fondu*
3 parts sand

## Mixing concrete

When the quantities of concrete involved are small, it is simpler to mix your own material. The concrete should be mixed in an old bowl (eg a baby bath), on a clean, hard surface or on a platform of boards. It is important to use clean sand, clean aggregate and clean water. All ingredients, including the water, should be carefully measured. For small quantities, buckets are convenient, provided they are all the same size. Use one bucket for the cement and a second bucket for the sand, the coarse aggregate and the mixing water. It is especially important to keep the mix uniform for different batches when using coloured cements or aggregates.

For an ordinary concrete mix, take one bucket of cement, two of sand and three of gravel or stone chippings, and about $\frac{3}{4}$ bucket of water. It is important to measure the correct amount of water, as the shape of the bucket makes it difficult to estimate quantities by eye. Do not use too much water; the drier the mix, providing it is workable, the better the concrete will be. First, form a flat circular layer with the measured quantity of coarse aggregate, then add the measured quantity of sand. Add the cement, mainly in the centre and mix by turning twice with a shovel. Form a central crater and pour $\frac{1}{2}$ to $\frac{2}{3}$ of the total water. Then sprinkle the dry material from the outside into the centre and turn it over, adding more water from a watering-can fitted with a fine rose. Knead with the flat of the shovel to speed the mixing, and continue turning until the mix is uniform. It is most important to ensure that the materials are thoroughly mixed after adding the water.

## Filling the mould

Concrete should be placed in the mould within one hour of mixing. It must be well compacted, by tamping with a blunt piece of wood. Wherever possible the cast should be made hollow for lightness. To keep the compacted concrete in place against the walls of the mould, sand can be poured into the hollow. Once the concrete has hardened the central core of sand can be poured out. The figures opposite show other methods of filling moulds. Lengths of mild steel reinforcements should be embedded in the concrete where any parts of the sculpture are structurally weak. Slightly rusty metal is best as it forms a good key with the cement. Any scale on the metal should be removed with a wire brush. It is important that there is no oil on the metal. Bolts or any other type of fixing should be embedded in the concrete before it sets. The concrete must be kept damp for as long as possible to assist curing by wrapping the mould in a sheet of polythene.

The shape of some moulds requires that the pieces are filled before they are reassembled. When the mould is reassembled, some liquid cement can be poured into the seams to join the pieces. If any seam is accessible, strips of glass fibre should be placed across it and the liquid cement stippled through with a long handled brush. This makes a much stronger join that liquid cement alone.

*If the neck of the mould is wide enough, a two-piece mould can be assembled and then filled. This diagram shows the mould filled so that the cast is hollow*

*Very narrow sculptures have to be filled solid*

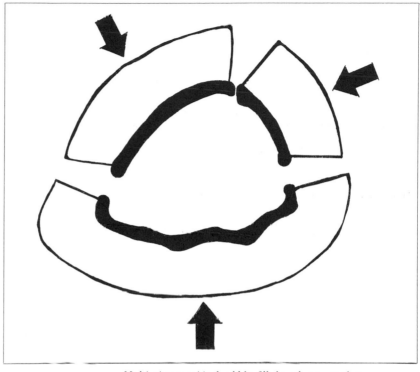

Multi-piece moulds should be filled so that parts that become inaccessible when assembled have a small, extra ridge of cement that is built up on the surfaces to be joined. This is done before the mould is assembled. When the pieces of the plaster mould are reassembled, these concrete ridges are squeezed together so that they join

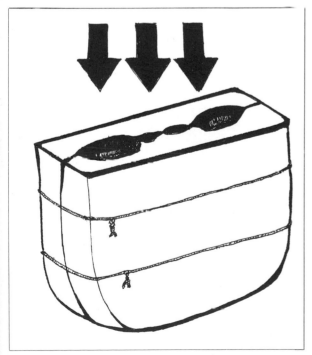

Some moulds may be filled using a combination of filling the various pieces of the mould separately, assembling them and then packing in cement through any accessible openings to bind the pieces together

# Setting times

There are 3 stages that take place after the addition of water to the cement mix:

1  *Setting time* is the period in which the cement solidifies and binds the aggregate and begins immediately after the water has been mixed with the cement. The setting time varies according to the type of cement used (see table).

2  *Hardening* takes place after the concrete has become solid. This is an important time in which the concrete starts to develop its strength.

3  *Curing* is the period for development of strength in the concrete and depends upon prolonged favourable conditions, such as a damp atmosphere so the concrete does not dry out. Once the cement is allowed to dry out, curing stops. A good cure is therefore dependent upon the retention of water in the concrete.

The following table is a guide to the usual setting, hardening and curing times of Portland and high alumina cements.

| Cement | Setting time | Hardening time | Curing time |
|---|---|---|---|
| Portland cement | 10 hr | 3 days | 21 days |
| high alumina cement *ciment fondu* | 3 hr | 7 hr | 24 hr |

*Note*  Remember to wash down the surface on which the concrete was mixed as soon as work has been completed and take care that the cement and sand do not get into the drains. A dry sweep of the area before washing down is advisable. Also wash any tools that have cement on them.

# Casting a sculpture in ciment fondu

(model)  (mould)   (cast)
clay  →  plaster → *ciment fondu*

The photographs in the following section show the casting of a group of clay figures into *ciment fondu*. A plaster mould is made in this example but *ciment fondu* could be used in moulds made of hot melt compounds, cold cure silicone rubbers and glass fibre. Plaster moulds must always be thoroughly soaked before filling with *ciment fondu*.

### The armature
The armature is prepared for modelling the clay sculpture. The armature is ready made – it was originally an oven shelf. It is painted with a rust inhibitor to prevent rusting, which would discolour the clay. It is then bound with galvanised wire to give a better surface for the clay to adhere to. The armature is nailed to a board to keep it upright.

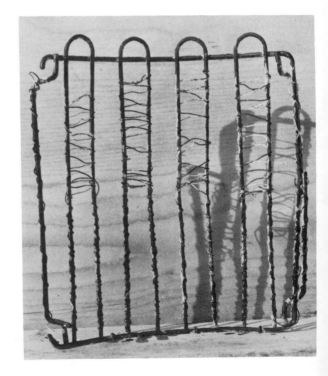

## Placing the shims in position

The sculpture is prepared for casting by constructing a shim fence around it, so that it is divided in half. The spaces between the figures are also divided in the same plane, by sliding in pieces of shim that are cut to fit. Registration shims (keyways) and clay wedges are also placed in position (see pages 60–61).

## Clay wall and clay wedges

To prevent the plaster running off the board, a clay wall about 2 cm ($\frac{3}{4}$ in.) in height is positioned around the base and about 2·5 cm (1 in.) from the sculpture.

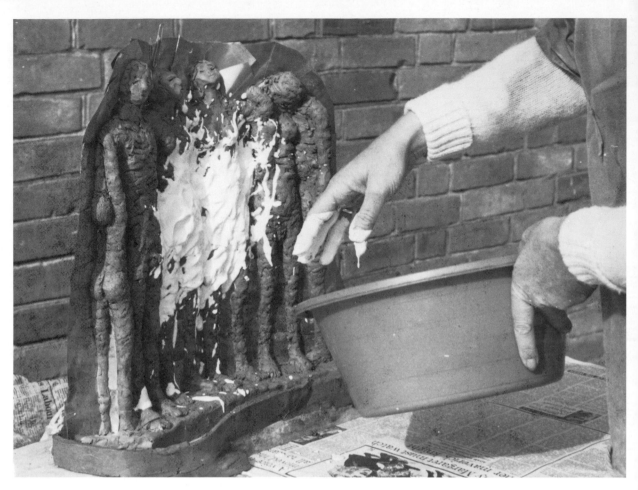

## Making the mould

A bowl of plaster is mixed to the consistency of single cream. As this is the layer of plaster that takes all the detail, it is vital that the consistency of the mix is not too thick and that it covers the sculpture with a thin, even coating. If the plaster has been mixed too thick, it is wiser to throw it away and to mix another batch rather than risk spoiling the sculpture. The first layer of plaster should be applied so that the sculptor's hands never touch the model. This is done by holding the bowl of plaster close to the model with one hand and by dipping the fingers of the other hand into the plaster. The plaster is transferred to the model by a quick upward and out-ward movement of the hand, terminating in a flicking action of the fingers

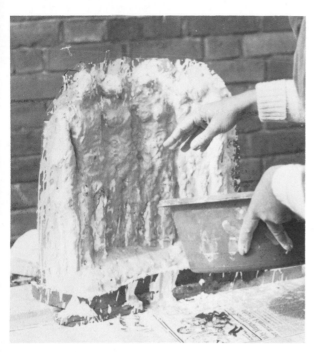

## Applying a coloured layer of plaster
Many sculptors include some coloured powder paint in the first layer of plaster. The advantage of this is seen when chipping away the mould. The coloured layer gives, when it becomes visible, a warning that the chisel is getting close to the sculpture. This helps to avoid accidentally chipping the cast. To apply a coloured layer, mix a water soluble powder paint in the water before adding the plaster. Dipping a blue bag in the water is an alternative way of colouring the plaster.

The plaster should be built up in an even layer either side of the shim fence, over the whole surface of the sculpture. The shim edge should be scraped clean after each new application of plaster.

## Clay wash
A very thin clay wash may be painted over each layer of plaster before applying the next. The advantage of the clay wash becomes evident at a later stage when the plaster mould is chipped away from the cast. The separating effect of the clay wash helps the layers of plaster flake away more easily.

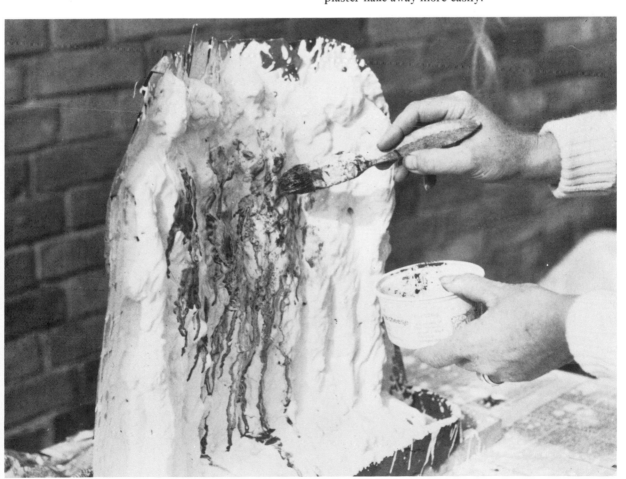

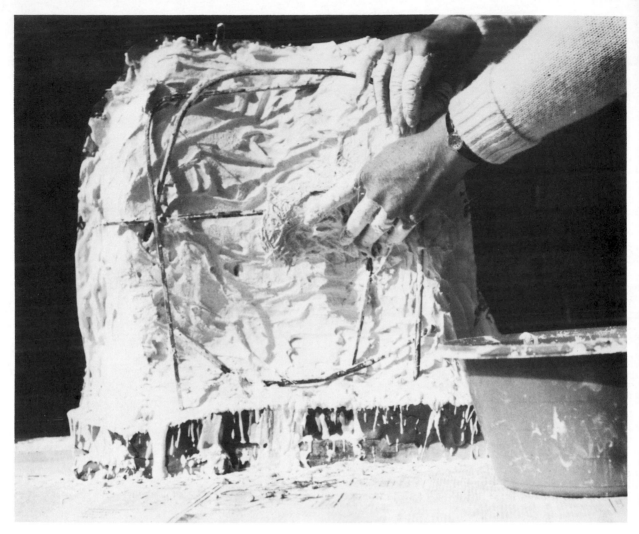

## Reinforcement

Layers of plaster should be built up to make a mould thickness of approximately 2 cm ($\frac{3}{4}$ in.). Some reinforcement should be put in position before the final layer of plaster is added. Mild steel bars, which must be free of grease, are generally used because they are strong and can be cut and bent to the mould shape without too much difficulty. The metal bars can be held in position with strips of scrim or glass fibre dipped in plaster. Small moulds do not need metal reinforcement but can be strengthened with strips of scrim or glass fibre dipped in plaster.

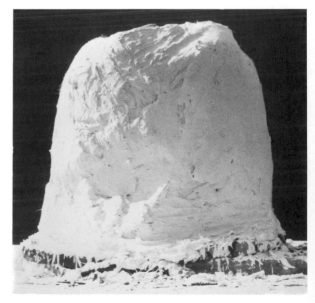

*The completed mould*

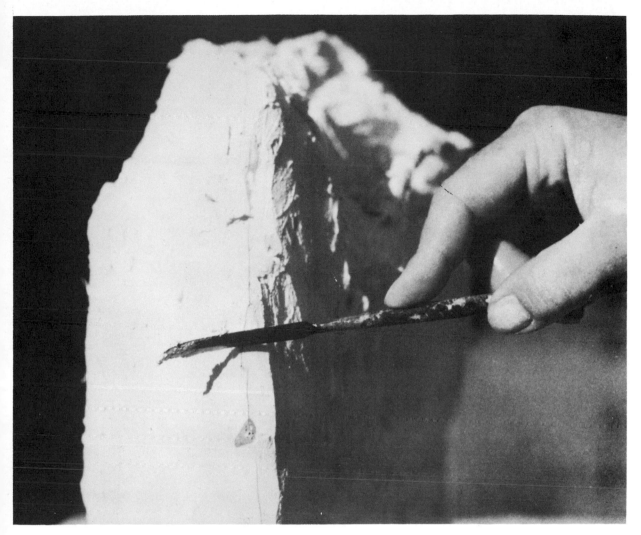

When both halves of the mould are complete the plaster is scraped back to reveal the top of the shim fence This is easier if done before the plaster has set hard. One of the clay wedges can be seen along the seam edge.

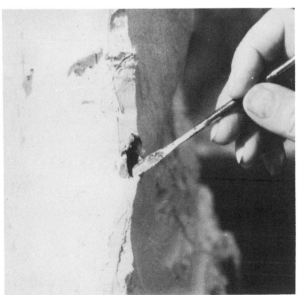

**Opening the mould**
Before the mould can be opened, the clay wedges should be gouged out with a thin metal tool.

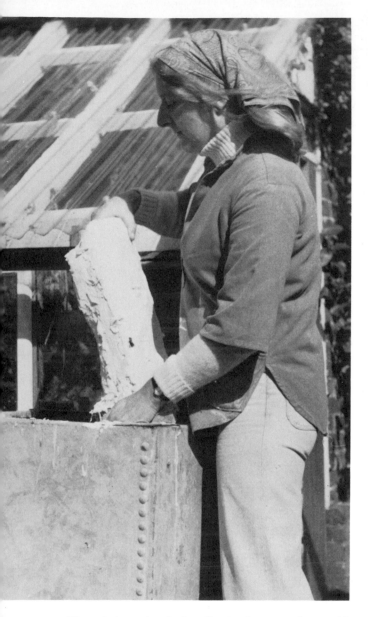

*Opening the mould*

Water helps to break the adhesion between the mould pieces. This can be done either by standing the mould in a tank of water or by pouring water over the mould so that it runs in through the holes left by the clay wedges. The mould can then be eased open by placing chisels in the holes left by the clay wedges. It is best to use two chisels, if possible, placed on each side of the mould. This ensures that the mould is levered apart evenly. Levering on one side only can cause the mould to crack. Gently lever the chisels backwards and forwards to free the mould pieces.

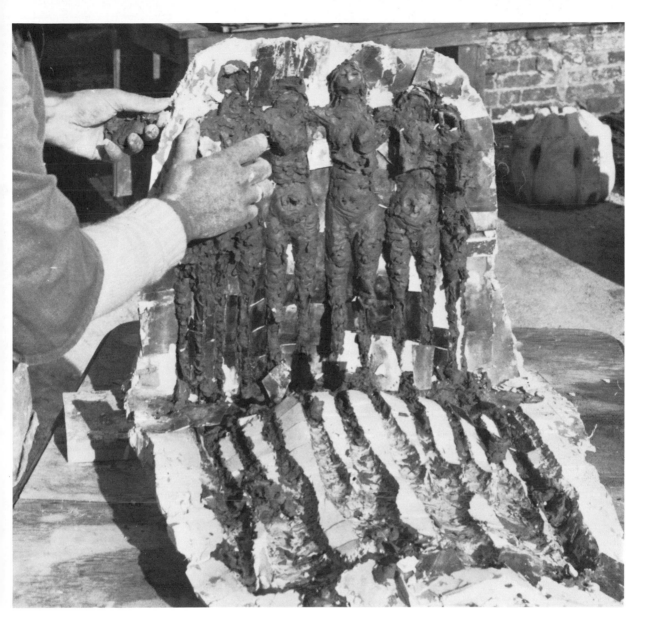

## Removing the model
When all the clay has been removed there is a fine clay
film left on the mould surface which makes a good release
agent. In the case of the sculpture shown in the photo-
graph, it was necessary to gently scrub the mould clean,
in order to remove all the particles of clay from the
textured surface. After scrubbing the surface, an applica-
tion of a release agent was made because the clay film had
been removed.

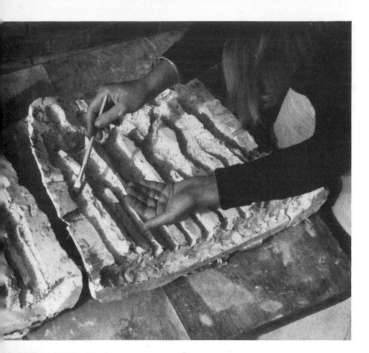

### Applying the release agent

A fine film of light machine oil was brushed over the mould surface. To avoid applying too much oil which would interfere with the setting action of the cement, a little was poured into the palm of the hand and the brush was dipped into this

### Filling the mould

As it would be impossible to fill the mould when assembled, it is necessary for each half of the mould to be filled separately. The smooth surface of *ciment fondu* is achieved by painting a layer of neat *ciment fondu* over the mould surface. This mixture of *ciment fondu* and water, which is called *goo*, should have the consistency of double cream. When painting it over the mould surface use a heavily laden brush. Do not re-work areas that have already been done as this will disturb the release agent.

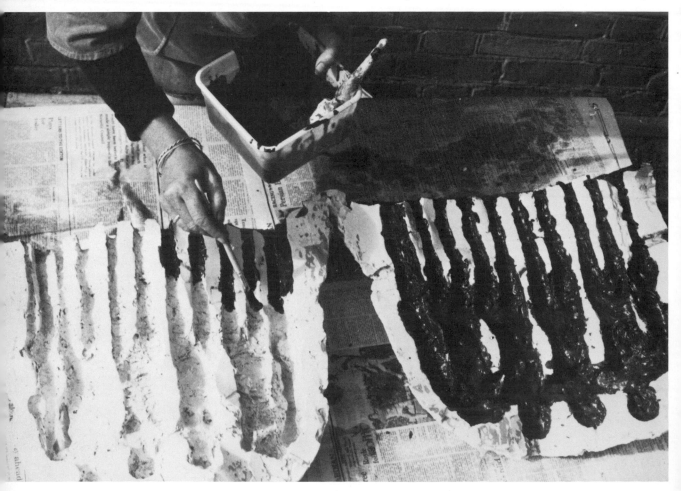

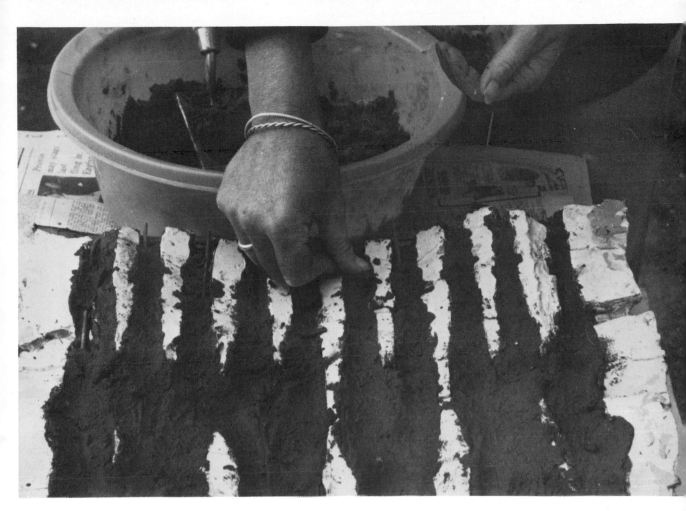

The main filling of the mould is a mix of *ciment fondu* and sand (1:3 parts by volume). These ingredients should be thoroughly mixed in their dry state before adding just enough water to bind the mixture together effectively. Handfuls of the mix should then be dropped into the mould and gently tamped with a blunt piece of wood. As this mould is shallow and has narrow sections, the mixture is compacted by thumb pressure only.

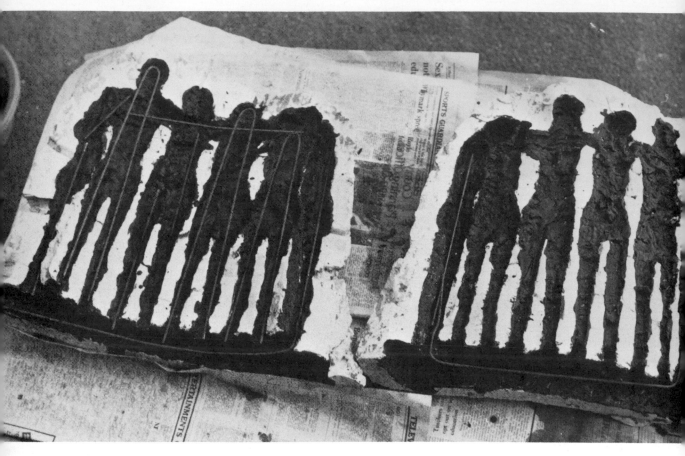

### Reinforcement
Before the mould is completely filled with *ciment fondu*, reinforcing irons are cut and bent to shape and then placed in position. More of the mix is then compacted over the reinforcing irons.

## Assembling the mould

Finally, the two halves of the mould are assembled. Provided the mix is well compacted and about one hour has elapsed during the filling, the mould may be held upside down while it is assembled, without risk of the *ciment fondu* falling out. If the mix is rather wet, it is necessary to allow more time for the *ciment fondu* to harden slightly in the mould. Before assembling the mould pieces mix a small batch of sand and *ciment fondu* to a sloppy consistency and paint a thin layer on the surfaces to be joined. Make sure that the rim of the mould is clean, as particles of sand and *ciment fondu* will prevent the mould fitting together accurately. Once the mould is assembled, it should be secured firmly with wire. All accessible parts of the mould such as the base and the lower legs, are filled with the original *ciment fondu* mix and well tamped. This is to ensure that the two halves of the mould are integrated. Two bolts are embedded in the *ciment fondu* so that the sculpture can be fixed to a wooden base when complete. The seam that runs all the way round the mould is sealed with clay to help retain the dampness while the *ciment fondu* is curing. The mould is then wrapped in a sheet of polythene and left for at least 24 hours.

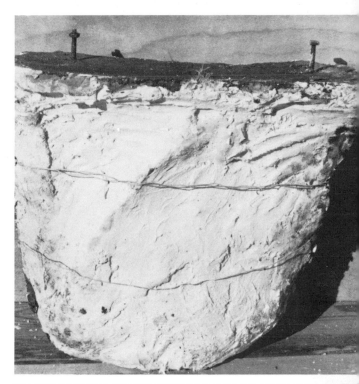

## Chipping away the mould

An old wood chisel and a wooden mallet should be used to chip away the mould. Care should be taken not to remove too much plaster at a time. Any structurally weak points of the sculpture should be left encased in the plaster mould as long as possible, for support. The clay wash that was applied when the mould was made should help the layers of plaster flake away easily. The coloured layer of plaster should act as a warning to the proximity of the cast.

## Cleaning up the cast

When the mould has been removed from the cast, there is often a feeling of disappointment at the appearance of the sculpture. Plaster leaves a whitish bloom on the *ciment fondu*. Some sculptors like the effect of the bloom but if it is not wanted it should be scrubbed off with water and a stiff wire brush as soon as possible, because the longer it is left, the more difficult it is to remove. Usually, time has to be spent picking all the plaster out of the surface detail of the sculpture. Pinholes caused by air bubbles and any damaged areas should be filled while the cement is still damp. If it has been allowed to dry out, it should be soaked before carrying out any repairs. A paste-like mixture of neat *ciment fondu* and water should be used to fill the holes. The whole sculpture should then be wrapped in a polythene sheet again and left for a further 24 hours. Any broken parts of the cast should be stuck with an epoxy type of adhesive. The adhesive will not work effectively unless the cement is completely dry.

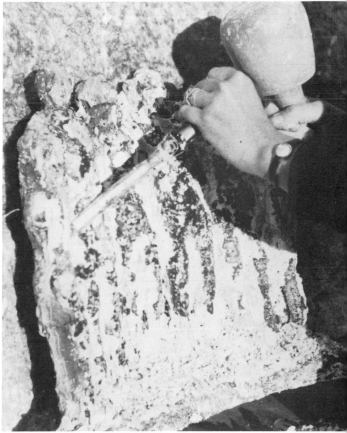

### Bolting the sculpture to a wooden base

A piece of card is placed over a block of expanded poly-
styrene and the sculpture is then pressed onto this so
that the bolts pass through the card into the polystyrene.
The holes made in the card mark the position of the
bolts. The outline of the base is then drawn onto the
card

*Base of sculpture showing bolts protruding*

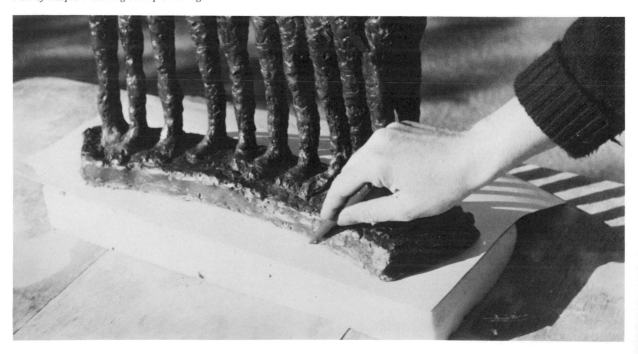

The shape of the base is cut out of the card. The card is then placed in the correct position on the wood base and the holes marked with a pencil

Holes are drilled through the base making sure that the diameter of the drill is the correct size for the bolts. These holes must be countersunk on the underside of the base so that the nuts may be recessed into the wood. The recessed nuts are tightened with a box spanner

## Finishes for ciment fondu

### Retaining the bloom
Some sculptors make use of the whitish bloom that is on the cast when it is removed from the mould. The bloom can be preserved by applying a coat of wax polish over the surface.

### Removing the bloom
The bloom is removed by scrubbing the surface with water and a wire brush. Alternatively, a wire brush attachment on an electric drill will remove the bloom effectively. The *ciment fondu* is then the colour of gun metal. Once it is dry the surface may be polished with a soft cloth and a wax polish.

### Applying a brass coloured finish
By brushing the sculpture with a brass suede brush, a brass-coloured deposit is left on the sculpture. This can also be applied by using a brass wire brush attachment on an electric drill. The application of a light spray polish on the cast before using a brass brush achieves a more brassy effect. The brass deposit on the sculpture lightens the colour of the grey *ciment fondu* which can be an effective way of highlighting detail and texture.

## Ciment fondu laminated with glass fibre reinforcement

*Ciment fondu* may be used without sand. In this alternative method, the cement is mixed with enough water to form a thick, creamy paste known as *goo*. The mould is then painted with a thick coat of goo. When this has hardened slightly, more is painted on and strips of glass fibre (chopped strand mat) are placed over it. The goo is then stippled through the matting. When the mould surface has been completely covered, a further two or three layers should be laminated in the same way. Any reinforcing irons needed to strengthen the cast should be laminated under the final layer of matting.

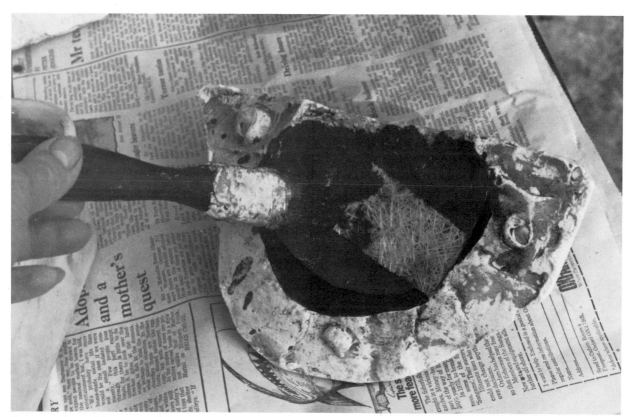

*Laminating a mould section with* ciment fondu *and glass fibre (chopped strand mat)*

# Making a sculpture base in ciment fondu and glass fibre

Black bases can be made cheaply from *ciment fondu* and glass fibre. (Also with *ciment fondu* mixed with polyester resin and reinforced with chopped strand mat.)

First a clay block is made to the size required for the base of the sculpture. This is done by scraping a metal square across the surface. To keep it level, it is supported each end on wood blocks of the same size

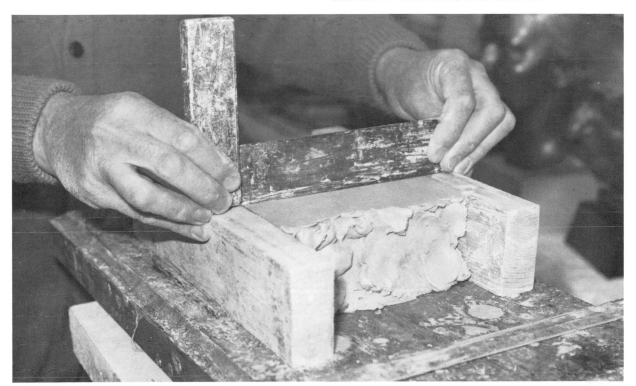

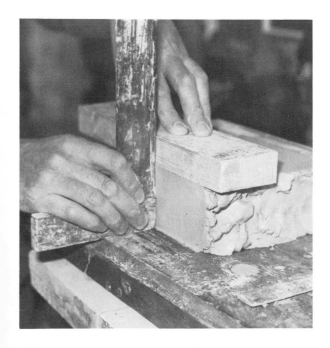

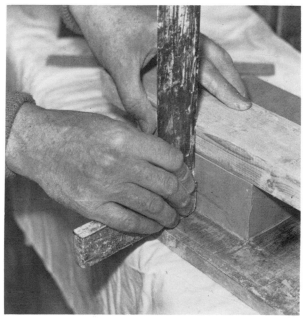

The clay block should then be completely covered in plaster to make a mould. The clay is then removed and the mould painted with a thick coat of neat *ciment fondu* and about three laminations of chopped strand mat impregnated with goo (for *goo*, see page 78). This method of reinforcing *ciment fondu* enables a light, hollow base to be made. The mould should then be wrapped in polythene for 24 hours before chipping away.

*The completed clay block*

*The inside of the base showing the fibre glass matting*

*The completed base with holes drilled for the bolts*

# 7 Hot melt compounds

There are a number of brands of hot melt compound used for making flexible moulds. *Vinamold* and *Gelflex* are the best known trade names. These vinyl-based compounds make a flexible mould that is ideal for casting delicate sculpture and heavily undercut or textured surfaces. When heated, the compound becomes a liquid which is poured around the model and then allowed to cool and solidify.

Moulds made of hot melt compounds offer a number of advantages. The mould pulls away cleanly from the cast; no separating agents are required; the original model can be made of clay, plaster, cement, glass fibre, metal, glass or any other rigid compound that does not soften at about 150°C (the melting point of the compound). Moulds are suitable for filling with plaster, cement, plastic stone and waxes. They are also suitable for use with glass fibre but this causes a more rapid deterioration of the mould. They can be stored for many years without deterioration. Alternatively, they can be melted down and re-used a number of times before they lose their elasticity. As the cast can be removed without destroying the mould, a number of identical casts can be made from the same sculpture.

## Preparation of sculpture for casting

A model of any rigid material can be used provided it does not soften at about 150°C, the melting point of the hot melt compound; thermoplastic resins are therefore unsuitable. Metal sculpture should be warmed to prevent cooling of the hot melt compound during casting. Cement or cast stone sculptures are best used water wet. They should be soaked for several hours, dried superficially and then used. Porous materials, such as dry plaster and wood, should be sealed to prevent trapped air bubbles marring the mould. Models that require sealing can be painted with several coats of shellac or of *G4* varnish. (For *G4* varnish see page 110.)

## Open moulds

Open or *flood moulds*, used for casting relief panels, are very simple to make. The model, providing it is in low relief, can be moulded in the following way. The panel is laid on a flat surface and a retaining wall of clay or wood 2·5 cm (1 in.) higher than the highest point of the model is built. The melted compound is then poured between the wall and the model in a continuous stream to avoid trapping air.

## Retaining walls for moulds

The simplest type of mould is made by constructing a retaining wall around the sculpture. The retaining wall can be made from a strip of oiled card or brass fencing (shim), rolled into a cylindrical shape and tied securely, to prevent it unrolling. This should be placed around the model so there is about 1·5 cm (½ in.) between it and any part of the model. The model should be fastened to the base to prevent it floating when the hot compound is poured. The retaining wall should be sealed to the base with clay, plasticine or masking tape to prevent seepage.

Anothar way of constructing a retaining wall is to use coils or slabs of clay round the model. The advantage of this is that an irregularly shaped sculpture can have a tailor-made wall.

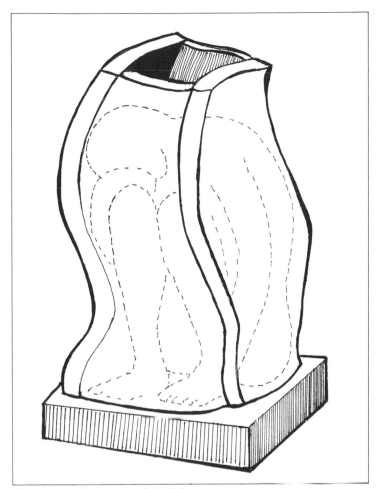

*A retaining wall made from coils of clay*

*A retaining wall made from slabs of clay*

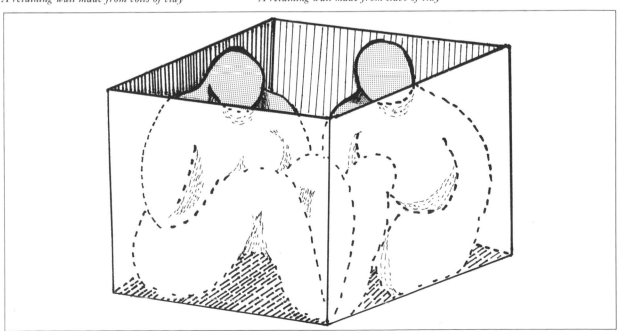

*The sculpture placed in a box to retain the hot melt compound*

89

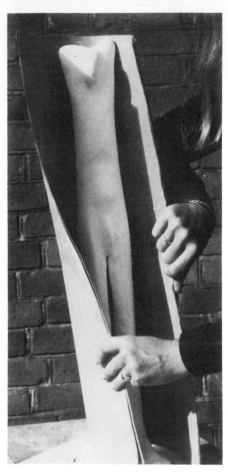

*A retaining wall constructed from a sheet of oiled card*

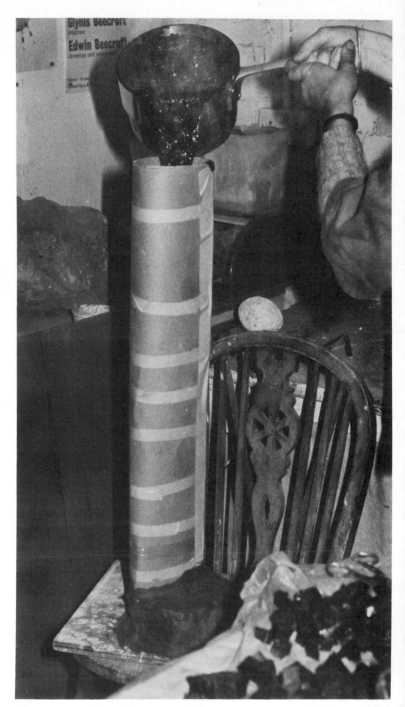

*The retaining wall taped in position. It fits into a lower part made from slabs of clay. This makes a neatly fitting wall around the wider base part of the sculpture*

*A melting pot for hot melt compounds*

## Containers for melting hot melt compounds

The containers used to melt *Vinamold* or any other make of hot melt compound should be made of aluminium, stainless steel or tin. Copper and zinc are unsuitable. For small quantities, a saucepan can be used over a gas ring or electric hot plate. The saucepan should be placed on an asbestos mat. This is an absolute necessity when a thin bottomed container is used. The ideal method is to use an air bath, which is similar to a double saucepan but has hot air instead of hot water in the outer vessel. Boiling water is not hot enough to melt *Vinamold* or other hot melt compounds. An air bath can be made out of two tins of different sizes, with the smaller tin hanging in a hole cut in the lid of the larger one. Melting pots should have a well-fitting but not air-tight lid to help to reduce the fumes. An air bath can be used for quantities up to 4.5 kg (10 lb). Larger quantities should be melted in a thermostatically-controlled electric melting pot. Melting pots for 1 to 2.5 kg (2 to 5½ lb) quantities can be bought from sculpture suppliers. These have a cast iron base and an aluminium saucepan. They can be used with gas or electricity and are well worth the investment.

## Melting procedure

Cut the hot melt compound into small pieces, about 2.5 cm (1 in.) square. Drop a handful of these pieces into the saucepan and start heating them gently. A cast iron melting pot will take about 10 minutes for the outer vessel to heat up sufficiently to start melting the rubber. Stir with a wooden spoon or stick immediately the rubber begins to melt, to prevent it burning. Wait until all the lumps have melted before adding the next handful. Melting hot melt compounds is quite a slow process. The melting time of 0.5 kg (1 lb) of rubber is approximately 30 minutes; 2 kg (4½ lb) is 60 minutes; and 3 kg (6¼ lb) is 90 minutes to 2 hours. It is important not to increase the heat too quickly or the rubber will burn. To avoid over-heating the rubber, it is advisable to use a thermometer (available from sculpture suppliers) to check the temperature. The appearance of streaks with a distinctive dark shade indicates that the rubber is beginning to burn. Also the rubber will begin to feel stringy and will give off excessive fumes. If this happens the heat should be reduced and the saucepan removed from the source of heat for a few minutes. A slight discolouration of the rubber during heating is normal.

Continue to add small handfuls of rubber, stirring frequently. When sufficient quantity has been melted, check that there are no lumps left. Remove the saucepan from the heat and allow to stand for a few minutes so that any air bubbles rise to the surface.

## Safety precautions

Read carefully the manufacturer's instructions when heating these hot melt compounds. The fumes given off during the heating are very unpleasant and may be harmful to health, particularly to anyone predisposed to respiratory disorders. The long term effect of prolonged exposure to these fumes is not known. It is advisable to find a sheltered position out of doors where the rubber can be melted. If the rubber has to be melted indoors, good ventilation is extremely important. The lid should be kept on the saucepan to reduce the fumes. Masks are available from sculpture suppliers and these can be fitted with filters.

There is a risk of the contents of the saucepan catching fire if some of the rubber spills down the edge of the saucepan. A gas flame can quite easily burn up this trail of rubber and into the pan. It is important to remove any spillage of this kind, immediately it happens. If the saucepan does catch on fire, turn off the source of heat immediately. **Always keep a carbon dioxide ($Co_2$) fire extinguisher close at hand. Do not use water because the burning compound will float.**

## Pouring of hot melt compound

Pour the entire quantity of melted rubber required in a steady, even and continuous flow. Pour the liquid between the model and its container, making sure that it runs on to the side of the container and not directly on to the model, as this will wash away the detail. The liquid compound should be allowed to rise around the model so that it drives out any pockets of air that would otherwise become trapped in the rubber mould. Fill to approximately 2·5 cm (1 in.) above the maximum height of the sculpture.

## Extraction from the mould

The model should not be removed from the mould until the rubber is completely cool. Leave the mould to cool and do not try to hasten cooling by submerging the mould in cold water. To remove the sculpture, gently flex back the walls of the rubber mould and carefully pull the sculpture free. It is sometimes necessary to slit the mould where there are excessive undercuts and where parts of the mould are linked eg where there is a gap between the body and an arm of the sculpture. The sculpture can be released by making a clean slit through the rubber with a sharp knife.

## Filling the mould

When the rubber mould is filled, it is possible that there will be some sagging and distortion in its shape. The best method to avoid this is to make a plaster casing that will support and retain the shape of the rubber mould (the technique is described on pages 94–109). If this is not possible, another method is to place the mould in a box and to surround it carefully with sand until the walls of the mould are completely supported. This is not quite as satisfactory as a plaster case, because it is possible, when packing the sand, for areas of the mould to become slightly distorted. The rigidity of the mould is greatly helped by making its walls quite thick (2 to 3 cm) ($\frac{3}{4}$ to $1\frac{1}{4}$ in.). The mould can be filled with plaster, cement, polyester resin, etc (see table on page 65). Release agents are not required.

## Repairing moulds

Occasionally, rubber moulds split. This can result if the mould is made too thin. Sometimes splits in the mould are in such a position that the weight of the mould keeps the sides of the tear pressed together. In this case there is no problem. However, it is sometimes necessary to repair the tear. There are a number of ways of doing this. One is to heat a little more rubber and to reseal the tear by 'buttering' the edges together, using a metal knife or spatula. Another method is to stick the tear together with a rubberized glue (the type used for sticking rubber soles on shoes is suitable). In this case the glue should be cut away and disposed of when the mould is no longer required, so that it will not become mixed with the compound when it is next melted and re-used. A third method of repair is to use a needle and some strong linen thread and to stitch the tear from the outside.

## Storing moulds

Rubber moulds should be inspected for cleanliness, all particles of dirt should be washed off and the moulds then dried and stored for further use. With careful treatment moulds can generally be remelted 7 to 10 times.

## Plaster cases

Sculptures that are fairly small can be cast using the type of retaining wall already described. Larger sculptures generally require an outer case of plaster as a retaining wall for the hot melt compound. This takes longer to make but is the most efficient and accurate method of casting from rubber moulds. Without a plaster case to support the mould, the casts are likely to be distorted.

Sculptures that are fairly simple in shape can have a rubber mould made in one piece. The plaster case should be made in two halves for easy access to the mould. The following section shows the general outline of the technique for making a one-piece mould and plaster case. The second section shows the procedure for making a two-piece mould and plaster case. As the principle is the same for both methods, I have included the details of the procedure in the second section, which is the more complicated of the two approaches.

# Making a one-piece *Vinamold* mould and plaster case from a sculpture in *ciment fondu*

(model)        (mould)        (cast)
*ciment fondu* → *Vinamold* → plaster

To prepare the *ciment fondu* sculpture is should be soaked in water or sealed with *G4* varnish. The undercuts are filled with pellets of clay to make a fairly smooth surface. Clay is rolled out and placed over the sculpture to cover it completely. (Later this clay layer is removed and liquid rubber poured in its place.)

In preparation for making the plaster case in two halves, a shim wall is placed around the sculpture. A clay funnel is made and clay risers placed on high points, to avoid trapping pockets of air when the hot rubber is poured.

The plaster case is made by building up plaster over the layer of clay. The top of the pouring hole and risers should be scraped back before the plaster sets, to reveal the clay. When the plaster has hardened, the case is opened. (The layer of clay that covered the sculpture is not visible because it is stuck to the plaster case.)

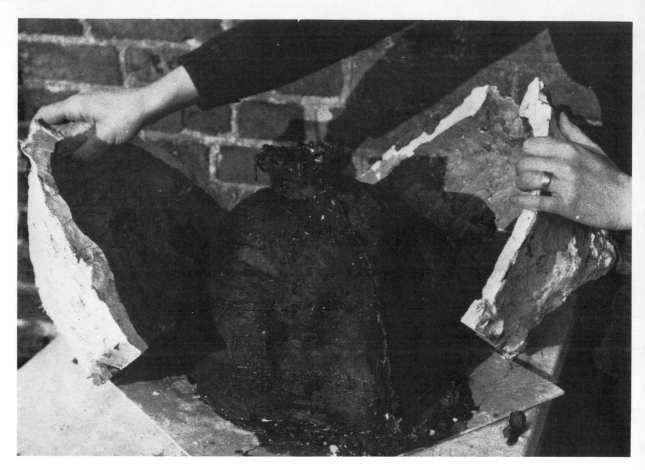

All the clay is removed from the sculpture and case. The plaster case is reassembled around the sculpture, sealed to a base and the seam filled with plaster to prevent leaks. *Vinamold* is melted and poured in through the funnel hole. When it is cool the case may be opened

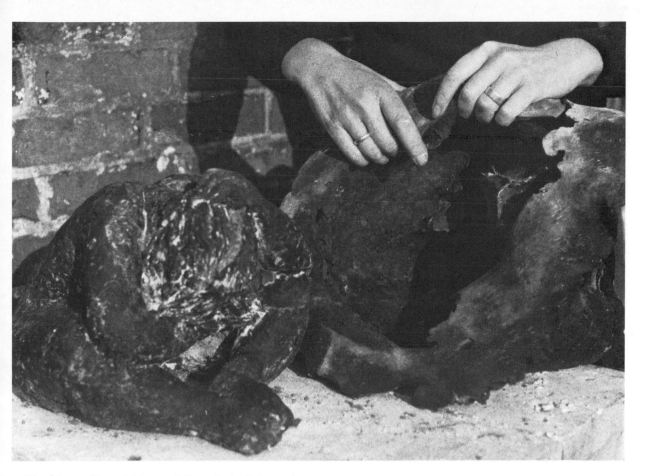

The *Vinamold* mould is carefully pulled off the sculpture. It is then ready to be reassembled in the plaster case, for making the casts

## Making a two-piece *Vinamold* mould and plaster case from a clay sculpture

(model)      (mould)      (cast)
clay   →   *Vinamold* →  plaster

### Casting from a clay model

Before commencing, check that the clay has reached the correct consistency. If it is too wet it will be easily damaged and if it has dried out too much it may crack or contain air that will expand and spoil the surface of the mould. As clay is used for constructing the plaster case, the clay for modelling the sculpture should be different in colour. This allows for clear differentiation during the process. In the photographs below the model was made in red clay and the working clay was grey.

### Preparation of the clay model

The sculpture is laid flat on a bed of soft clay that has previously been covered with thin polythene (laundry bags are useful for this). A clay surround is built to divide the sculpture in half horizontally, bricks or wood blocks being used to support the clay at the required height. The clay surround should be 4 to 7 cm (1½ to 2½ in.) wide and there should be a gap of about 0·05 cm (¼ in.) between this and the model. Undercuts or spaces (eg between the limbs of figures) should be filled with rolls of clay dusted with French chalk to prevent them adhering to the model. The purpose of this is to keep the outer surface of the rubber mould as smooth as possible, so that the plaster case will lift off easily without damaging the clay model

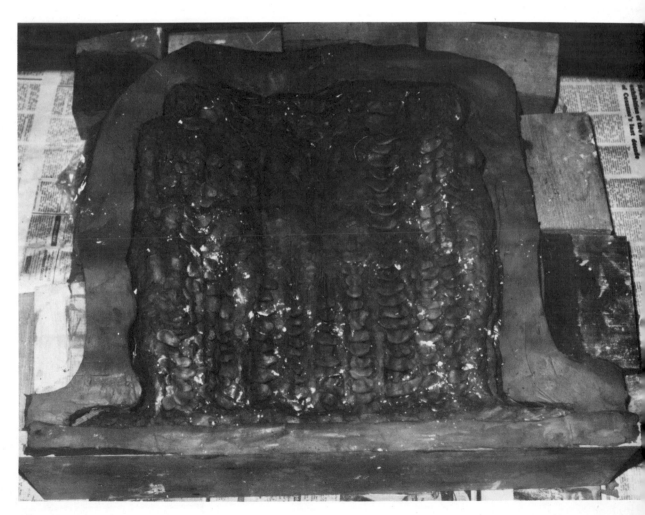

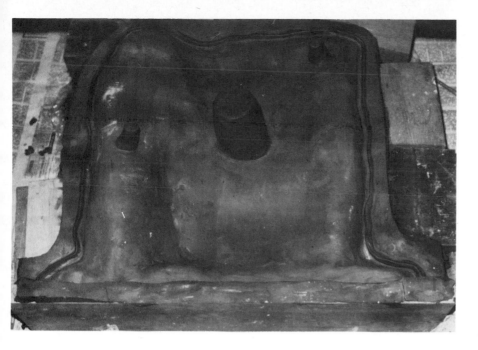

Pieces of clay are rolled out to a thickness of about 0·5 to 0·75 cm ($\frac{1}{4}$ to $\frac{3}{8}$ in.). The sculpture is then covered with a sheet of polythene film ('cling film wrap' works well). The sheets of clay are then carefully positioned over the model and any joins between the pieces blended together to make a smooth surface. A pouring hole and risers are made from truncated cones of clay. The pouring hole should be positioned centrally and a riser is needed wherever there is a high point, to avoid pockets of air forming in the case when the rubber is poured. Finally, an inverted 'V' key edge is laid around the model to provide the rubber mould with a locating groove in the finished plaster case

## Making the first half of the plaster case

The first half of the plaster case is made by flicking plaster on the surface and building it up to an even thickness; about 1 to 2.5 cm ($\frac{1}{2}$ to 1 in.). Extra thickness should be added around the edge of the case and surrounding the cones – about 2.5 to 4 cm (1 to 1$\frac{1}{2}$ in.). Scrim or chopped strand mat should be used as reinforcement because the plaster case will be handled a good deal. If the mould case is very large, some metal reinforcement is a wise precaution. The plaster should be scraped back before it hardens, to reveal the tops of the clay funnel and vents. The edge of the plaster mould should be trimmed to make a neat line

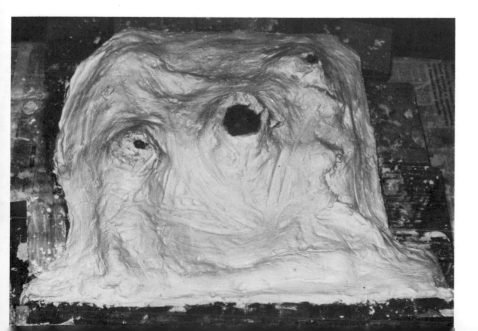

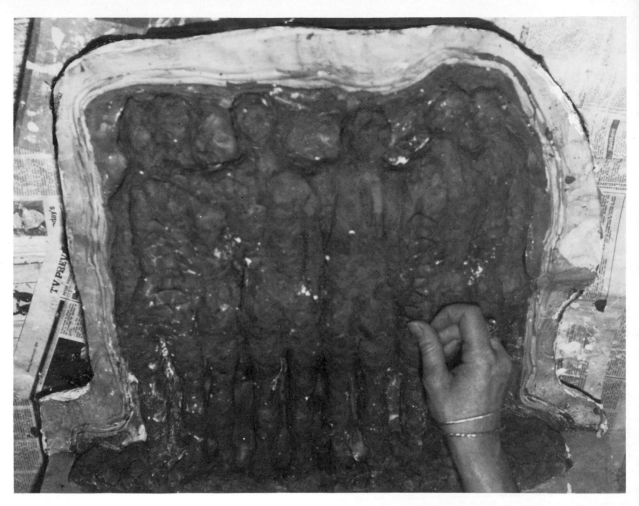

## Making the second half of the plaster case

When the plaster case has hardened (about 30 minutes), the blocks and bed of clay are removed and the sculpture is turned over so that the completed half of the plaster case is underneath. The clay surround is removed and the surface exposed and trimmed to remove any defects. Depressions are then made in the surround at intervals of 10 cm (4 in.), to provide a key for the other half of the plaster case. Rolls of clay dusted with french chalk are used to fill the undercuts, in the same way as for the first half

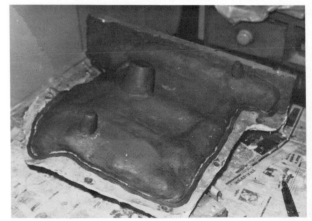

The model is covered with a layer of polythene film and then a layer of clay in the same way as the first half. The pouring hole, risers and 'V' edge are also added in the same way as before. Finally, the edge of the case is greased with *Vaseline* and the second half of the plaster case constructed, trimmed and then allowed to harden for an hour.

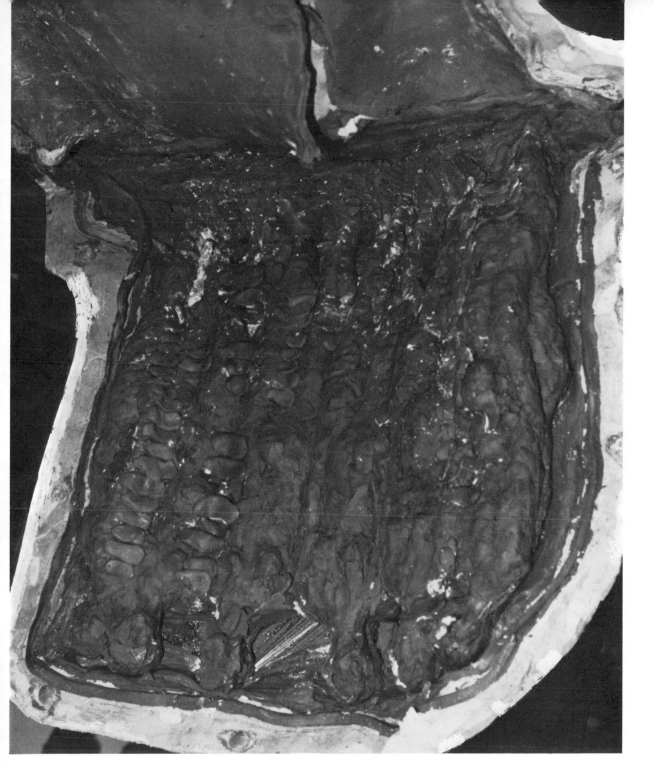

**Opening the case**
Turn the case over so that the first half of the case is uppermost. Carefully place a chisel in the seam edge and tap lightly. Repeat this at 4 or 6 points around the edge until the case lifts

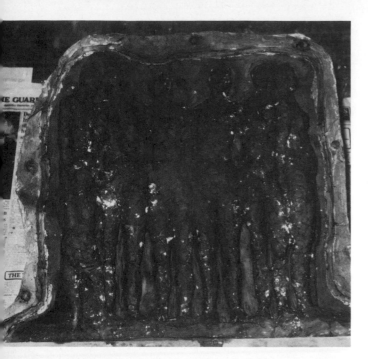

Carefully remove the rolls of clay and then re-touch any parts of the model that have been grazed or damaged

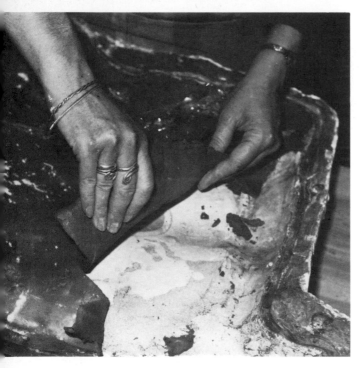

Remove the layer of clay from the plaster case and straighten up any irregularities

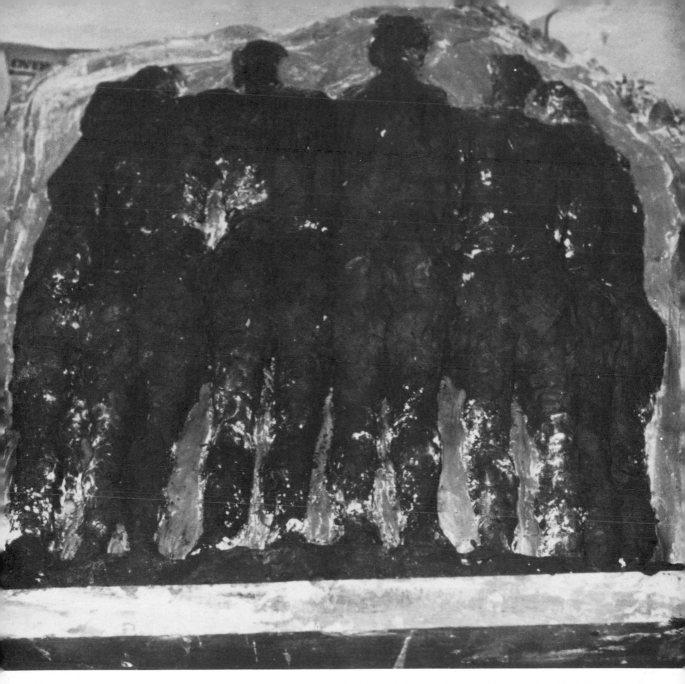

## 'Bedding in' the model

The model must then be *bedded in*. This is done by filling with clay the gap between the model and the case in which it lies. This must be done with extreme care, taking the clay right up to the surface of the clay model. This area of the model must be prepared beforehand by dusting it with french chalk to prevent the clay adhering. A small, flat, boxwood spatula is the best tool for this job. The clay infilling should be given a smooth surface and then keyed at intervals of 5 cm (2 in.) with a round-ended tool or a piece of dowelling. The spaces between the figures should be filled in the same way. This

'bedding in' procedure prevents the liquid rubber seaping into the other half of the mould. Before assembling the top half of the case, it should be soaked in water. This prevents adhesion or air bubbles when the hot melt compound is poured. Soaking is not necessary if the pouring of the rubber follows soon after the construction of the plaster case.

Great care should be exercised when replacing the plaster case to avoid knocking or scraping the model. The two halves of the plaster case are then clamped together with metal dogs. This is where the value of making the case with a strong edge becomes evident.

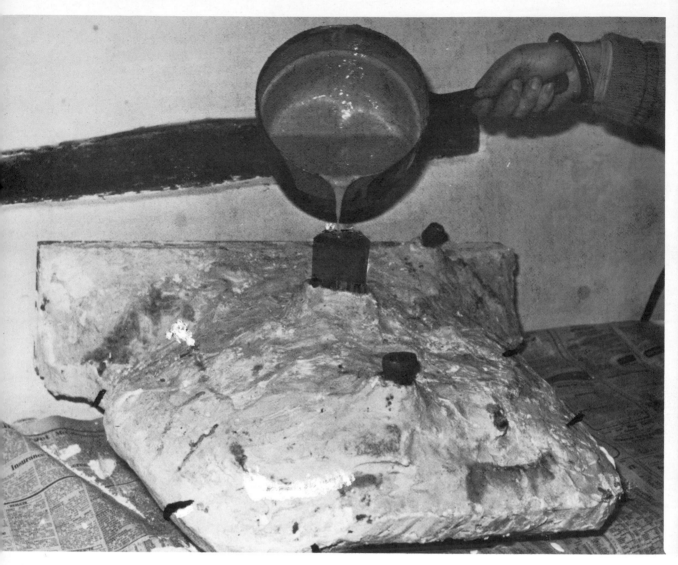

## Pouring the hot melt compound

It is important to pour the hot melt compound with a good head of pressure. This can be done by fitting an extension over the pouring hole to raise the height of the pouring point. A tin with the top and bottom removed can be used for this purpose. It can be set in a ring of clay to hold it firmly in position. Pieces of clay should be left nearby so that the risers can be plugged when the liquid rubber reaches their level. The hot melt compound should be poured at a temperature of around 120°C. If it is any cooler there will be a tendency for it in solidify before it reaches the furthest points of the mould. The liquid rubber should be poured in a steady and uninterrupted flow. If it is necessary to use more than one pan of rubber, they should be heated in quick succession to avoid separation of the rubber

Allow at least 3 hours for the hot melt compound to harden before turning the plaster case over. Remove the metal dogs and scrape away the plaster seam. The top half of the plaster case can then be gently lifted off, the clay removed and the case prepared as described for the first half. Dust any exposed areas of the rubber mould, ie between the figures and around the edge of the mould, with french chalk to prevent the two halves adhering. Carefully reassemble the case and pour the hot melt compound as described for the first half.

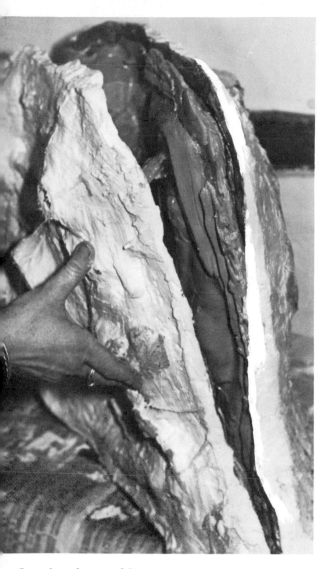

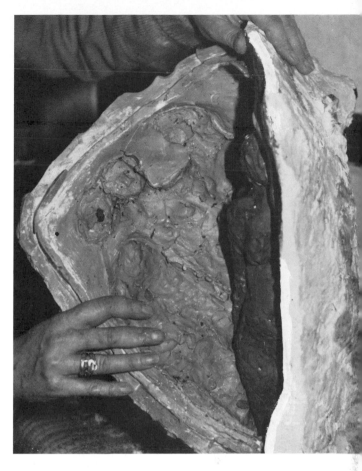

Gently flex the rubber mould away from the clay model. The clay model should be retained, if possible. This is so that the casts can be compared with the model and any defects retouched

**Opening the mould**
When the second half of the rubber mould has set, carefully remove one half of the plaster case

Cut off the pouring hole and vents from the rubber mould with a sharp knife and trim any loose pieces of rubber around the edge with a pair of scissors

Apply shellac to the inside of the plaster case. Two coats of shellac should be applied, allowing time for the first coat to dry before applying the second

**Making the cast** (facing page)
Assemble the plaster case and rubber mould, making sure that they are correctly aligned. Hammer metal dogs in position (see Glossary). If the mould is to be filled with a liquid casting material, it is wise to seal the seam, pouring hole and vents in the plaster case with plaster to prevent leaks

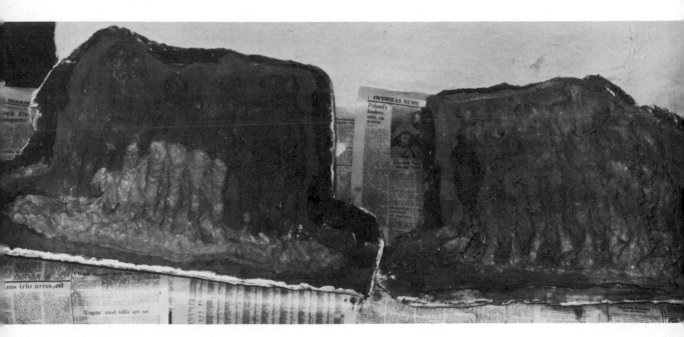

Clean the two halves of the rubber mould to remove any particles of clay or plaster. (The colour difference in one half of the mould is caused by a slight colour difference in the two pans of *Vinamold* that were used)

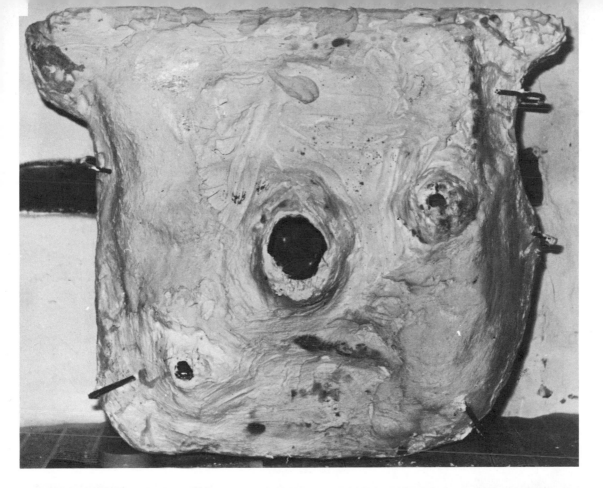

Vertical rods are placed in each leg and horizontal rods are placed along the length of the base (view from above)

Pouring the liquid plaster (*Crystacal R*) into the mould

The mould is opened to reveal the cast

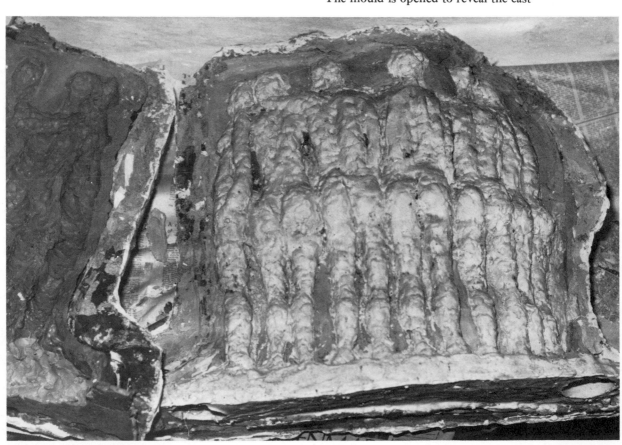

### Cleaning up the cast

Once the cast has been removed from the mould, it is necessary to remove seam lines, etc, with a sharp knife, small files and glasspaper. When the plaster cast is completely dry, the whiteness of the plaster can be camouflaged with an application of colour

## Finishes for plaster casts

The whiteness of plaster gives a rather glaring, lifeless appearance to the cast. For this reason sculptors often camouflage the plaster with some form of colour treatment. Colour may be added as part of the plaster mix before it is poured into the mould or it may be applied as a surface treatment.

## Integral colour treatment

Any colour applied to plaster must be lime free. Earth colours and metallic oxides are most suitable. The best method is to spoon some powder colour onto a square of fine muslin and tie it tightly. This can then be dipped in to the mixing water (like a blue bag) before the plaster is added, until the desired colour is reached. Remember that with the addition of white plaster the colour will be considerably lightened. This method avoids the streakiness that occurs when paint is added to the liquid plaster.

An alternative method is to mix powder colour thoroughly with dry plaster before adding the water. The advantage of colouring the plaster mix is that scratches and chips are not so evident.

## Superficial colour treatment

Substances used for surface colouring of plaster include oil paint, emulsion, tempera, shoe polish, metallic finishes, and resins.

The usual way of applying colour to the surface of plaster is first to apply several coats of diluted PVA glue, shellac dissolved in alcohol, or polyurethane varnish. The plaster must be perfectly dry. Each coat applied must be allowed time to dry completely before the next is applied. In the case of polyurethane varnish, it is necessary to rub the surface lightly with very fine glass-paper between coats and before applying the colour.

Milk can be used to change the external appearance of plaster. Repeated saturation of sculpture in milk, with thorough drying out between each application, will give a marble-like effect. Another method is to add skimmed milk to the mixing water before the addition of powdered plaster. The plaster can then be polished when dry.

Shoe polish is sometimes used to mask the whiteness of the plaster. This can be applied with a brush or cloth and buffed to a shine. The wide range of colours provides a good choice and it is worth experimenting with several colours. If oil colour is to be applied, the plaster should first be soaked thoroughly in linseed oil. The oil colour may then be painted on directly and when dry, the surface should be rubbed lightly with silk. Varying degrees of transparency can be achieved, depending on the amount of turpentine used to dilute the oil colour.

Uniform coloured effects can be achieved with aerosol paint sprays, car paint sprays or any household paint. The plaster should first be primed with a paint primer, shellac or varnish, using several coats painted directly onto the dry plaster surface.

In order to preserve the whiteness of plaster several coats of a durable, washable emulsion will seal the surface effectively. Alternatively, the plaster can be treated with several coats of clear varnish or white shellac.

## Bronzing

This technique gives plaster sculpture a simulated bronze effect. Plaster surfaces should be free from moisture and sealed with shellac. Bronze powder can be bought in small jars in a variety of metals such as green bronze, medium bronze, light gold and copper. To apply the metal powder, each colour should be mixed with a small amount of shellac and painted on with a soft brush. Sometimes more than one coat is necessary. The usual technique is to paint the sculpture with a dark earth colour (eg raw umber), then to paint on a medium bronze and copper mixture, leaving a little of the umber showing in the deepest hollows. Finally, a light bronze is applied to the projecting parts to highlight them. To remove any garish quality, a tin of graphite is useful. This can be applied in small quantities with the bronze powder. Graphite is a useful powder as it is cheap and can be used on its own with shellac, to create lead coloured effects on the plaster. After bronzing the cast, a coat of wax may be applied to help protect the surface.

## Metallic finishes

There are tubes of a metallic coloured cream that can be rubbed on a surface to give a simulated metal effect, and then buffed to a shine. They can be bought in a number of different metal colours and are sold in most art shops. The plaster should first be sealed with several coats of shellac before applying the paste.

## Resin finishes

A more durable finish can be achieved by coating the surface of the cast with polyester resin, containing a colour pigment or metal filler. When small quantities are required, packs containing resin, metal filler and hardener are useful. An excellent product of this type is *Devcon*. (See suppliers' list.) *Devcon* is a metallic epoxy resin that can be painted over plaster to give a durable surface with a glossy, metal-coloured finish. Plaster should first be sealed with a coat of polyurethane varnish. *Devcon* is sold in different coloured finishes, such as bronze, aluminium, steel and lead. The packs contain the plastic metal, hardening agent, release agent (not required for use as a surface finish), measuring spoons and complete instructions. The plastic metal contains a high amount of metal (about 80 per cent) and a small amount of epoxy resin (about 20 per cent), which gives a fairly realistic effect. When the plastic metal has hardened, the gloss can be removed and highlighting effects achieved by rubbing lightly with fine steel wool.

## G4 varnish

This is a one-component plastic resin that is moisture-cured (ie it cures through the moisture in the air). It may be used as a sealer on porous material (including concrete) and as a varnish. It can be used with bronze powders instead of shellac. *G4* varnish may be obtained from sculpture suppliers and some builders' merchants. It is important to read the instructions before use.

# 8  Cold cure silicone rubber

Room temperature vulcanising (RTV) silicone rubber was introduced as a mould making compound about 20 years ago. There are a number of different types of RTV which have been developed for specific purposes in industry. The type recommended for mould making in sculpture is *RTV 700* silicone rubber. It is described as a cold cure silicone rubber because it does not require any application of heat.

RTV silicone rubber is expensive but has a number of advantages. It is a high-strength, flexible mould-making rubber, reproducing the finest detail. It is ideal for sculptors who do not have the facilities to heat the hot melt compounds, as it is clean, easy to use and does not smell strongly. Moulds made in silicone do not require a release agent and the sculpture can easily be removed by stripping back the mould. Multiples of the same sculpture can be cast from one silicone rubber mould. At least 10 copies are possible. A disadvantage of RTV is that once the mould is finished with, it cannot be melted down and re-used like a hot melt compound.

Silicone rubbers are usually sold in a tin or drum (depending on the quantity) with an accompanying container of catalyst. Manufacturers' instructions should be followed carefully.

## RTV 700

There is a variety of types of silicone rubber to choose from, but the most useful for sculpture is called *RTV 700*. Suppliers will advise on the correct silicone rubber to use for a specific purpose. *RTV 700* is the name of the main compound (often referred to as the base) and its setting action is brought about through the addition of a catalyst.

There is a choice of two catalysts that may be used with RTV – *Beta 1* which is green in colour and *Beta 2* which is red. The choice depends on the way in which the mould is to be made. If the rubber is to be poured into a mould box or retaining wall, then *Beta 1* catalyst is used. If the mould is to be made by spooning or 'buttering' the rubber onto the sculpture (to make a skin mould) then *Beta 2* catalyst should be used. Once *Beta 2* has been mixed into the base compound, it remains flowable for 30 minutes and butterable for the next 45 minutes. This enables the mould to be built up to sufficient thickness to give dimensional stability. Moulds can be stripped from the model after about 3 hours. *RTV 700* can be used for making casts in polyester and epoxy resins or low melting-point alloys, as well as the usual range of casting materials.

### Measuring
Most RTV silicone rubbers are mixed with the catalyst in a ratio of 10:1 (check manufacturer's directions). If the whole container of silicone rubber is required to make the mould, then the accompanying container of catalyst will contain the correct quantity to mix into it. When a different quantity is required, it is necessary to use a small platform scale to weigh the correct amounts.

### Mixing
The silicone rubber base and catalyst should be mixed in a container about 4 times the size of their combined volume. Mixing can be done by hand, using a spatula or a paint stirrer. Alternatively, a power mixer may be used. The strong colour of the catalyst and the white base compound, make it easy to ensure a uniform mix. This is absolutely essential to the curing of the mould. The sides of the container should be scraped several times during the mixing operation. It is also a good idea to pour the contents into another container to make sure they are thoroughly mixed. Care should be taken when mixing that air bubbles are not incorporated, as this will result in air pockets in the mould.

# Making the mould

There are three different methods for making a mould in silicone rubber. They are as follows:

### 1 Making a mould box

Retaining walls can be made round the sculpture using cardboard, thin metal or clay. Alternatively, the sculpture can be stood in a box. *Lego* bricks make an excellent mould box. The retaining walls should be sealed to the base with clay or double-sided adhesive tape to prevent leakage. The sculpture should then be stood in the box and the silicone rubber (catalysed with *Beta 1*) poured into the corner in a steady, even flow so that it pushes the air ahead and out of any cracks and crevices. The level of the rubber should be 1 cm ($\frac{1}{2}$ in.) above the height of the sculpture. Sometimes the level of the silicone rubber falls as a result of air escaping and the rubber settling around the sculpture. Check the mould about 15 minutes after pouring and top it up to the correct level if necessary.

This method tends to make a rather thick mould which can be a disadvantage as the rubber is expensive and the sculpture may be difficult to remove.

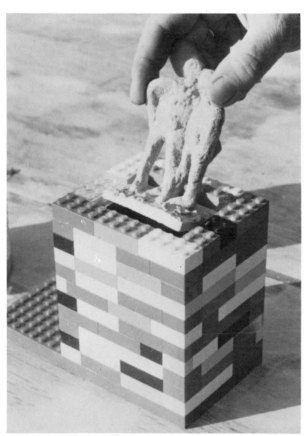

Placing the sculpture in a mould box made of Lego bricks

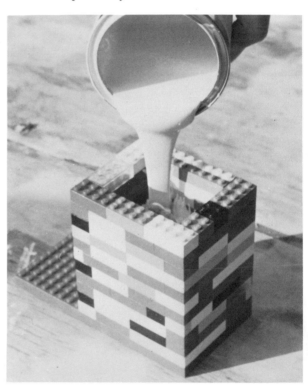

Pouring in the silicone rubber

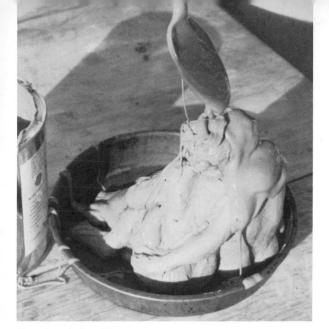

*Spooning on the rubber*

## 2 Making a skin mould

Skin moulds may be made by brushing a thin coat of silicone rubber (catalysed with *Beta 2*) over the sculpture. Apply the first layer with a brush, this helps to avoid trapping air bubbles on the surface of the mould. The silicone rubber can then be spooned on and as it thickens, it can be trowelled on with a knife. Skin moulds may be strengthened with mutton cloth or bandage. This type of fabric reinforcement should be cut into pieces of suitable size to cover the mould surface. They are then placed over the mould and gently patted until they have been incorporated into the rubber. Another layer of rubber can then be applied and a second layer of reinforcement if necessary.

*The completed skin mould*

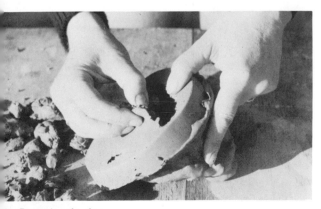

*Removing the clay*

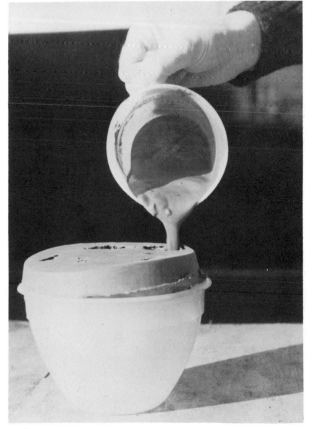

*Filling the mould*

113

## 3 Making a plaster case

A more accurate method of making a mould in silicone rubber is to make a plaster case to contain the rubber. When it is necessary to make the mould in more than one piece, this is the most reliable way of keeping the sections in position. It is a more laborious procedure but it is worth doing, as many identical casts can be made without any distortion. The following section describes the process in detail.

# Making a two-piece silicone rubber mould and plaster case

(model)    (mould)          (cast)
clay  →    silicone rubber → plaster

The sculpture was made by a student at the Royal Academy School, London, to demonstrate the technique of constructing a silicone rubber mould in 2 pieces. Before the silicone rubber can be poured over the sculpture, it is necessary to make an outer case of plaster. The plaster case (or jacket) acts as a containing vessel around the sculpture, to retain the liquid rubber while it is solidifying. In order to leave a gap between the sculpture and the plaster case, a layer of clay is temporarily placed over the sculpture. Once the plaster case has been made, the layer of clay is removed and the cavity that remains between the sculpture and the plaster case is filled with liquid silicone rubber. This solidifies round the sculpture and forms a flexible mould.

Before beginning the process, the clay sculpture should be exposed to the air until it becomes 'leather hard'. If the clay is too soft, it will be damaged when it is covered with the layer of clay. The first half of the sculpture is covered with a thin layer of polythene. This is to prevent the layer of clay that is placed over the sculpture from adhering and damaging the work. (A dusting of french chalk may be used instead of polythene.) A piece of clay is then rolled out and fitted and trimmed so that it neatly covers the first half of the sculpture

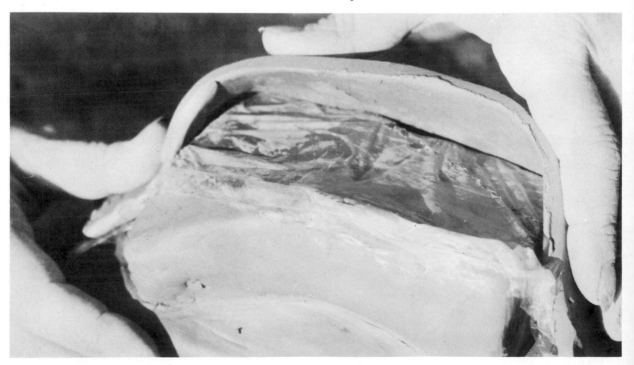

*Half of the sculpture covered with a layer of clay*

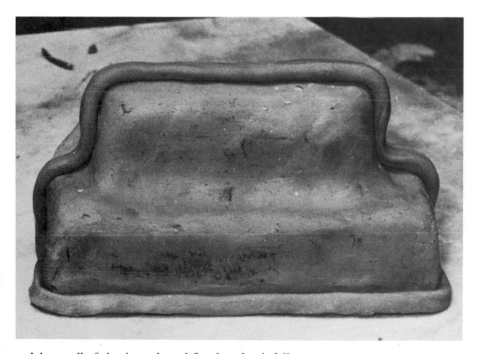

A long roll of clay is made and fitted so that it follows the line of the division between the two halves of the sculpture. A roll of clay should also be fitted around the base of the same half of the sculpture. This forms (at a later stage) the locating groove between the plaster case and the silicone rubber mould, so that they stay locked in position

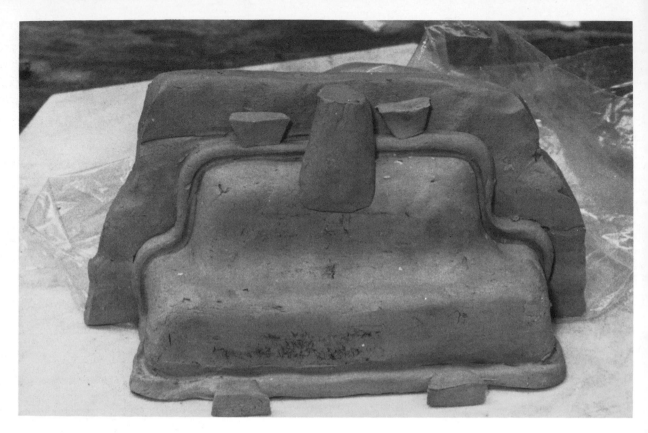

A wall of clay is built up at right angles to the sculpture. Wedges of clay are positioned around the sculpture as locating keys. At a later stage, when the silicone rubber mould has been made, these locating keys will form a type of press stud which helps to keep the flexible rubber mould locked in position in the plaster case. A thick piece of clay is rolled into a solid funnel shape and pressed onto the layer of clay. This forms a pouring hole at a later stage

Round indentations are made in the clay wall as registration holes. They can be made with a round-ended knife. A clay wall is positioned around the base of the sculpture, leaving a gap of about 1·5 cm ($\frac{3}{4}$ in.). Plaster is then mixed and applied to the sculpture

The plaster is built up over the first half of the sculpture to a depth of about 1·5 cm (¾ in.). The plaster should be scraped back before it sets, to expose the top of the clay pouring funnel

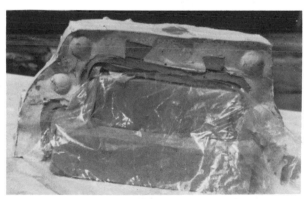

The sculpture is then ready for the other half of the plaster case to be made. The clay dividing wall has been removed and the registration points can be clearly seen. The plaster surface and registration points should be painted with a thin clay wash, to prevent the two halves of the plaster jacket adhering. The sculpture is covered with a layer of polythene in preparation for the clay covering

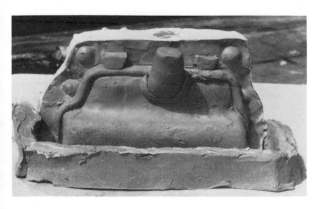

The second half ready for the application of plaster. The funnel, rolls of clay, clay locating keys and clay wall are all constructed in the same way as for the first half

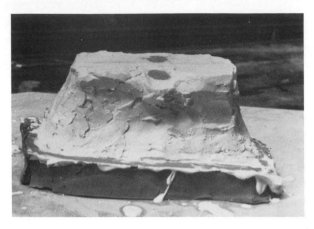

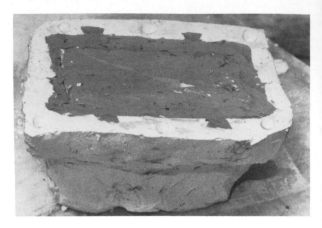

The second half of the plaster jacket is made and the top scraped back, to reveal the clay pouring hole

To seal off the base of the plaster jacket so that the liquid rubber does not run out, it is inverted and a base section made in plaster. Registration holes are cut in the plaster edge. The plaster edge must also be painted with a clay wash as a separator

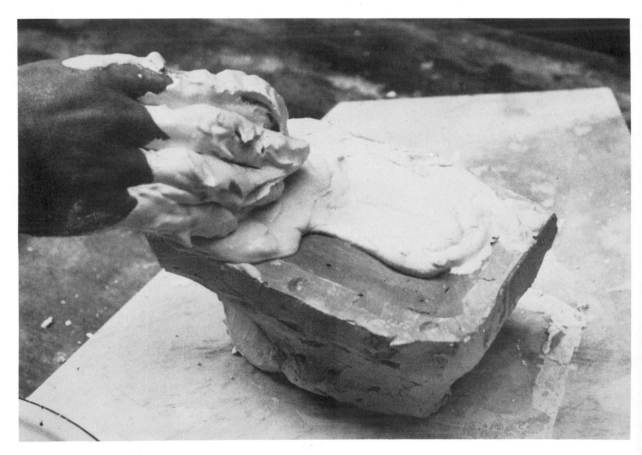

Making the plaster base section of the jacket. As an alternative to making a base section the plaster jacket may be carefully sealed to a board with clay.

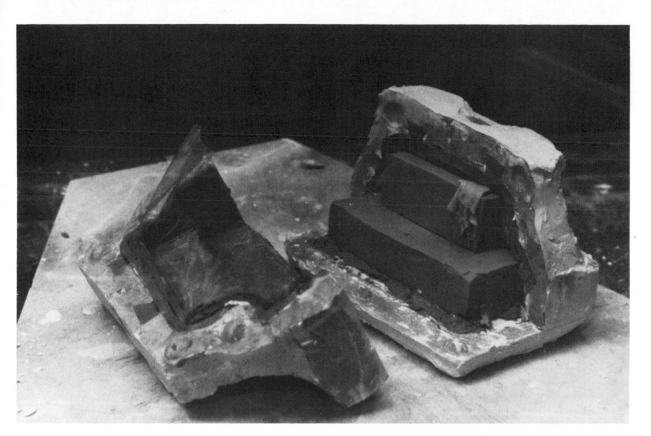

When the plaster has hardened (about 30 minutes), one half of the plaster case can be gently prised off. This is done by placing a wood chisel in the seam between the two halves and gently easing the case off. If there is any difficulty the whole case should be immersed in water for a few minutes, to break the suction. As the silicone rubber is poured into only one half of the plaster mould at a time, the other half of the case is left in position around the clay model. Any gaps between the clay sculpture and the half of the plaster case still in position around it, should be filled with clay. This is to prevent the liquid silicone rubber from seaping into the other half.

To prepare the first half of the case, the polythene and clay are removed, and the inner surface is painted with 2 coats of shellac to seal it. When the shellac has dried, a thin coat of *Vaseline* should be applied as a separator. This is to prevent the silicone rubber adhering to the plaster.

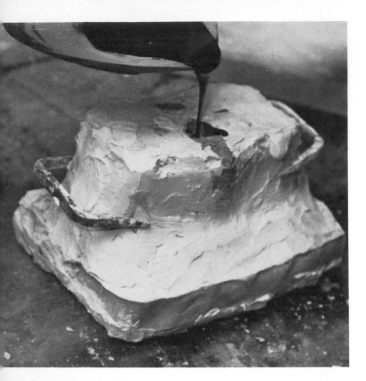

The two halves of the case are reassembled and clamped in position with metal dogs (see glossary). The seam between the two halves of the case should be sealed with plaster to prevent seepage. The cold cure silicone rubber is then mixed thoroughly with the catalyst (follow the manufacturer's directions) and poured into the first half. The liquid rubber fills the cavity that remains after the removal of the layer of clay. The silicone rubber should then be left to solidify.

To open the plaster case, the plaster that was applied around the seam to seal it must be scraped off with a sharp knife or *Surform* file. The other half of the plaster case is then removed. The first half of the rubber mould can be seen solidified around the sculpture

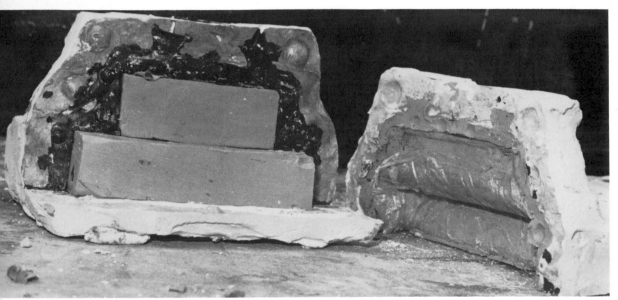

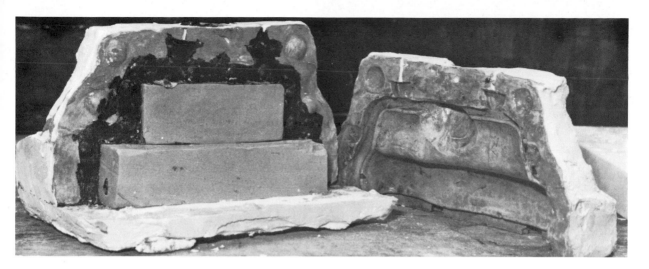

The clay layer, wedges, funnel etc, have been re-moved and the inside of the second half of the plaster jacket sealed with shellac and *Vaseline* as already described for the first half. The silicone rubber mould surface that is visible should be smeared with a little *Vaseline* to keep the two halves separate. The plaster case is then reassembled, clamped in position, and the seam sealed with plaster. Silicone rubber is then thoroughly mixed with its catalyst and poured into the second half

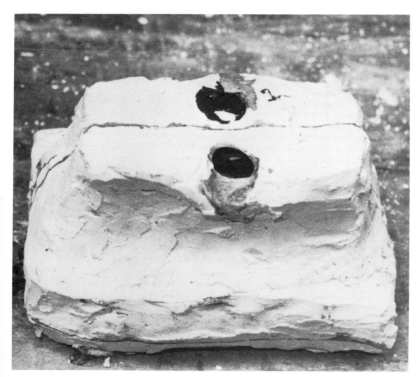

*The completed mould and plaster jacket*

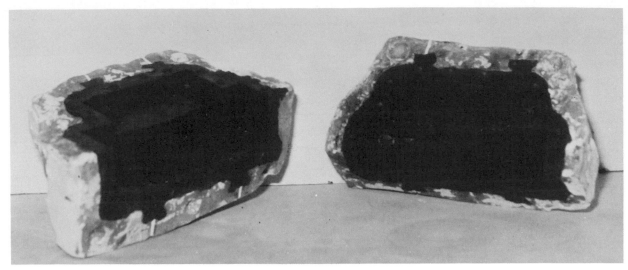

*The two halves of the mould after the clay has been removed*

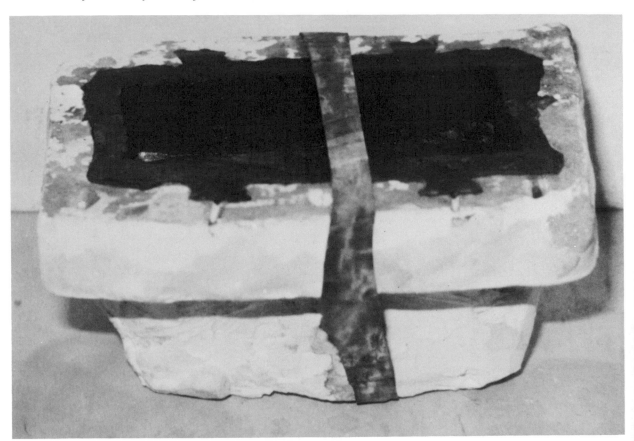

*The mould assembled and taped in position ready for filling with plaster*

# 9  Latex rubber

Moulds made in latex rubber are the same as those sold in craft and toy shops. The main disadvantage in making moulds from latex is that the reproduction of detail is not as good as from silicone rubber or hot melt compounds. Latex rubber moulds have a very limited life when casts are made from polyester resin.

Latex moulds are most successful when taken from a model made in plaster of paris. The porosity of the dry plaster ensures that the latex adheres well, resulting in good moulds.

## Making a latex rubber mould from a plaster model

The model used for casting with latex should be made from good quality plaster of paris. The plaster model should have a plaster base with a minimum thickness of 1·5 cm ($\frac{3}{4}$ in.). If the base is not made at the same time as the model, then a base may be added to the model by using the following procedure.

### Making a base
Make a circular plaster disc to a minimum thickness of 1·5 cm ($\frac{3}{4}$ in.). This can be done by pouring the plaster into a round, flat-bottomed container made of plastic or polythene. Yogurt cups and cottage cheese containers are useful for making small bases. Drill the bottom of the plaster model and insert a *Rawl-plug*. Drill a hole through the centre of the base and fix with a screw. Gaps between the model and the base should be filled with a cellulose filler such as *Polyfilla*. Plaster should not be used for this operation.

### Making the mould
The model, plus base, should be left in a warm place to dry out thoroughly. The model should then be placed in an oven at a temperature of approximately 80°C (176°F), until it is just bearable to hold. The model is then slowly lowered, base first, into the latex compound. This should be done by standing the model on an aluminium tray supported by aluminium, stainless steel or nylon rods or wire. A flat aluminium saucepan lid, with holes drilled for the wires, is a good way of im-

provizing a suitable tray. The model is left, completely immersed, for a minimum dwell time of 2 hours. The approximate thickness of latex deposited is as follows:

| Dwell time | Thickness |
|------------|-----------|
| 2 hr | 1·6 to 2·4 mm |
| 3 hr | 3·2 to 4·0 mm |
| 4 hr | 4·0 mm to maximum |

While the plaster model is immersed in the latex, it is advisable to cover the container. This will help prevent a skin forming on the latex and also dust or dirt settling on the surface. When the necessary dwell time has elapsed the mould should be slowly and evenly withdrawn from the latex. As a rough guide the withdrawal rate should be approximately 5 cm (2 in.) every 4 seconds.

### Drying the mould
The mould should then be left to air dry in its natural standing position for at least 2 hours, by which time the rubber should be 'touch dry'. The mould should then be placed in a drying oven at approximately 30°C (86°F) for a minimum of 3 hours. Alternatively, it may be left in a warm place such as an airing or boiler cupboard overnight. When dry, the mould should be dusted with talc or a weak detergent/water solution and stripped from the plaster model.

### Filling the mould
If the mould is reasonably small, it can be immersed in a sand-filled container to prevent any distortion when the casting material is poured in. For large moulds it is recommended that a case is made for the mould, from glass fibre or plaster. This should be constructed in two halves to facilitate removing the complete rubber mould and cast.

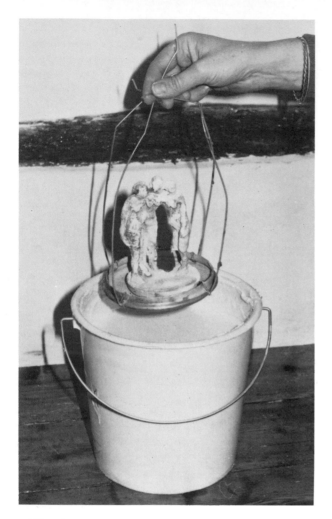

The plaster of paris model ready to be immersed in the bucket of latex rubber. Any gaps (eg between the figures, arms, and legs) must be filled with clay, otherwise it will not be possible to remove the model from the mould. The tray is made from an aluminium saucepan lid. The holes were drilled in it so that aluminium wire could be threaded through to hold it.

*Stripping off the mould*

## Latex moulds from other materials

Latex moulds may be taken from models made in other materials (such as cement, clay, wood and glass fibre) but the method of dipping the model in the container of latex is unsuitable. This is because the latex will not adhere to the surface of the model in the same way that it will adhere to plaster of paris. Moulds can be made from these other materials by spooning layers of latex rubber over the model and drying each layer before applying the next. The layers may be dried with a hair drier or a convector heater. The technique should be repeated until the mould is 2 to 3 mm ($\frac{1}{10}$ in.) thick. It is important that each coat of latex is not allowed to dry out too much or the layers will separate.

## Storage recommendations

Stored in well sealed containers, latex rubber will keep satisfactorily for at least six months. The latex must be protected from frost and should preferably be stored at a temperature of about 5°C (41°F) but not above normal ambient temperature. The latex should never be contaminated with copper or copper-bearing alloys. Latex contaminated in this way will age rapidly and the compound's useable life will be rapidly impaired.

*Latex mould and plaster model*

*Multiples cast in plaster from the latex mould*

# 10  Polyester resin and glass fibre

The glass-reinforced plastics (GRP) industry has grown rapidly since 1945. Before that time it was almost unknown, but now there are factories producing boats, water tanks, vehicle bodies, swimming pools, pipes and many other products in polyester resin and glass fibre. It is only in the last decade that sculpture in glass-reinforced plastics has become established. The material demands a precise and accurate working method and its smell and stickiness does not appeal to all sculptors. Nevertheless, its lightweight qualities and general versatility make it an important addition to the sculptor's range of materials. There are many comprehensive books on sculpture in glass fibre (see bibliography) and a glance through any one of these will leave few doubts about the complexity of the subject. As I could not hope to deal with the subject fully in the space available I have restricted this chapter to two of the basic techniques. These are the techniques of casting in cold cast metal and of making a mould in polyester resin and glass fibre.

## Laminating

The technique for working with glass fibre and resin is known as *laminating*. This basically involves brushing on a coat of resin over a surface previously treated with a release agent. A layer of glass fibre matting is then placed over the resin. By working the resin through the matting and repeating the process two or three times, a very strong, lightweight material is made.

## Materials

### Polyester resin
There are many different types of polyester resin. Some are used for fibre production (eg *Terylene*) and some are adhesives. The type used for sculpture is a cold curing polyester resin with a syrupy consistency. Most laminating resins already contain an accelerator, which is essential for the correct setting of the resin and are then described as *pre-accelerated*. The accelerator is usually a cobalt compound, which is deep blue in colour. When used in the small quantities required in polyester resin, it gives the resin its characteristic pinkish hue. The addition of a catalyst (liquid hardener) initiates a chemical reaction in which the liquid resin polymerizes to form a gel and then cures to form a solid, hard plastic.

At first the resin changes from a syrupy liquid to a gel which may take a few minutes, hours or even days, and depends on the amount of catalyst added, the room temperature and other factors. After the resin has formed a gel, it slowly cures to become a hard, non-sticky material. While the curing takes place, the chemical reaction produces a heat that can cause cracking and in extreme cases spontaneous ignition. It is therefore important not to catalyze large quantities of resin. Avoid pouring too much at any one time into the mould and leaving large amounts in a container (see safeguards page 128).

*Rigid laminating resin* and *thixotropic paste resin* are the two main types that the sculptor will require. *Rigid laminating resin* is a general purpose laminating resin that can be used for laminating both moulds and casts. It is non-thixotropic and has a pinkish tint because it is pre-accelerated. Laminating resin will drain rapidly off vertical surfaces and may cause dry patches. This is not a problem when working with a flat mould but with any other mould it is necessary to modify the laminating resin. This is done by mixing it with the *thixotropic resin*, which is basically the same as the laminating resin, except that it is completely non-drip. The use of the two types of resin gives great versatility as they can be mixed together in different proportions to produce a variety of viscosities. *Thixotropic resin* is not pre-accelerated, so follow the manufacturer's instructions regarding the quantities of accelerator and catalyst required. By adding sufficient thixotropic resin to the laminating resin a consistency can be obtained which will not run off the inclined sides of the mould.

*Warning*  Liquid accelerator and catalyst (liquid hardener), must never be mixed directly together because they will react violently. Always mix one into the resin before the addition of the other.

*Series A, No 1, 1968–9, William Tucker. Glass fibre*

## Catalyst
The catalyst, also known as liquid hardener, is added to the resin in very small quantities. The standard amount of catalyst to add to the polyester resin is 1 per cent but directions should always be followed carefully. When mixing small amounts it is important to measure fairly accurately in order to be sure of successful results.

## Glass fibre
Cured polyester resin tends to be brittle and has little structural strength, so it is generally reinforced with glass fibre (*Fibreglass* is the trade name of a firm producing this material). There are a number of different types of glass fibre. The main ones used for sculpture are woven glass cloth and chopped strand mat. Chopped strand mat is used in the examples in this chapter as it is adaptable and economical for making sculpture. Chopped strand mat consists of filaments of glass fibre that are cut in 5 cm (2 in.) lengths and are bonded together with a medium that dissolves when in contact with liquid resin. When the glass fibre mat is impregnated with a catalyzed resin and cured it makes a hard, strong,

rigid material that is suitable for making moulds and casts. Sculptors also use glass fibre surface tissue, a lightweight mat that is useful for laminating delicate or detailed parts of a mould, such as the ears of a portrait head. When impregnated with resin, the tissue fits easily into awkward parts of the mould. Several layers are usually applied, although surface tissue is not really a reinforcement and adds little strength to the resin.

## Fillers and pigments
Different types of filler in powder or granular form may be added to the resin. Almost any filler can be used provided it does not have an inhibitory effect on the catalyzed resin. Fillers may be minerals, metals or special compounds such as vermiculite. Inert fillers are used to reduce resin shrinkage, and to increase surface hardness and scratch resistance. Metal fillers give a metallic surface. Mineral fillers such as slate, stone dust and silica sand add colour and texture. Resin may also be coloured by mixing in pigments, which are available in a wide range of colours and opacities.

There is such a vast array of materials and equipment available that I have so far mentioned only the most basic, such as polyester resin, glass fibre, metal fillers, colouring agents and liquid hardener. All the other necessary pieces of equipment are mentioned where they occur in a process.

## Safeguards when using polyester resin and glass fibre products

There are certain procedures that should be observed when working with polyester resin and glass fibre in order to avoid any risk of fire and health hazards. The following list of safeguards should be strictly adhered to in order to avoid accidents.

1    Barrier cream (*Kerodex*) and overalls should always be used. When machining glass fibre, *Martindale* respirators and protection for the eyes must be worn.
2    Attention should be given to the provision of adequate ventilation.
3    Glass fibre materials must not be used or stored in the vicinity of a naked flame and it is strongly recommended that there is no smoking whilst handling the materials or in the workshop area.
4    Most resins have a limited shelf life. A three month stock may normally be considered economic and safe. Materials should be stored in cool, dry conditions. Materials not in general use are best stored in an external locked cupboard.
5    Catalyst and accelerator should never be mixed directly because they react violently. It is advisable to store them separately.
6    Lids and caps must be replaced immediately after use. Care in pouring materials is important. Catalyst should be used from an automatic dispensing bottle to avoid spillages.
7    GRP waste in small quantities can be burnt or placed in metal dustbins. Surplus catalyzed resin should be spread out to prevent high heat concentration.

**In the event of accidents**
**the following action must be taken:**
*Eyes*  If waste particles of plastic or organic liquids (catalyst) come into contact with the eyes, wash out immediately with clean water and if necessary consult a doctor.
*Skin*  Clean hands, etc, with *Kerocleanse* then wash well. If catalyst comes in contact with the skin wash off immediately.
*Swallowing*  Seek medical attention immediately.
*Clothing*  Resin spots on clothing can be removed (before they have hardened) with *Kerocleanse*, rubbed well into the area and then washed off.

*Reproduced by kind permission of Strand Glassfibre Limited.*

## General technique

1    Work in warm, dry conditions. Dampness inhibits cure and coldness retards cure.
2    Have materials ready before starting work. Cut glass fibre mat to size or if one piece of mat is to overlap the next, tear both edges instead of cutting. This gives a better join and the overlapped edges do not show.
3    Have a number of containers ready for the resin (waxed cartons or small polythene buckets are ideal) and clean sticks or a palette knife for stirring.
4    Have a container of acetone ready for cleaning brushes and rollers.
5    Add catalyst (liquid hardener) in correct proportion. Do not forget to add the accelerator to the resin if the resin is not pre-accelerated.
6    Do not forget to apply a release agent to the mould before applying the gel coat.
7    Trim the cast with a trimming knife while it is still in the mould and the resin is still in the 'green' stage, ie not yet hard. If the resin is left to harden it will be necessary to use a hacksaw or diamond tipped cutter.

# Casting a portrait head in cold cast bronze resin

(model) (mould) (cast)
clay → plaster → cold cast bronze resin

This section deals with the method of making a glass fibre cast from a portrait head in clay, using a plaster mould. The particular technique used is called *cold casting*. The finished cast has a metallic appearance, in this case bronze.

Materials and equipment needed for cold casting: laminating resin, thixotropic resin, acetone (for cleaning brushes), chopped strand mat and surface mat, bronze filler, sheet of polythene, mixing stick, soft brush (for applying PVA), old paint brush (for laminating resin), *Kerocleanse* (for removing resin from hands), scissors, paper towels. The roller is specifically designed for laminating resin and is only suitable for large, flat areas. In addition a release agent is also required. (See pages 63–64.)

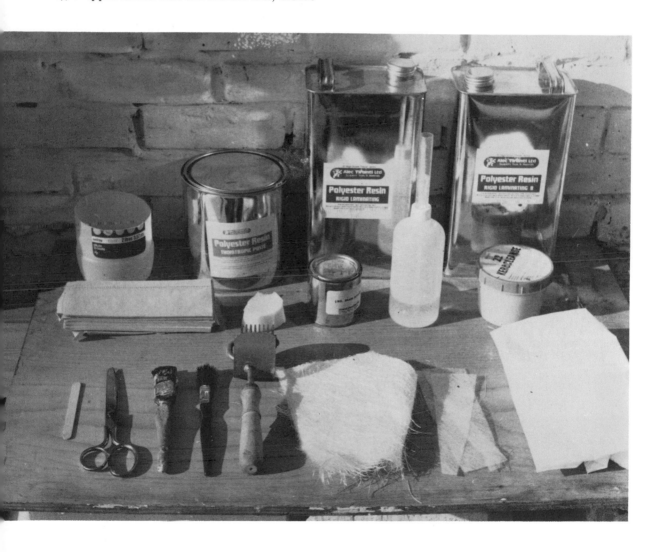

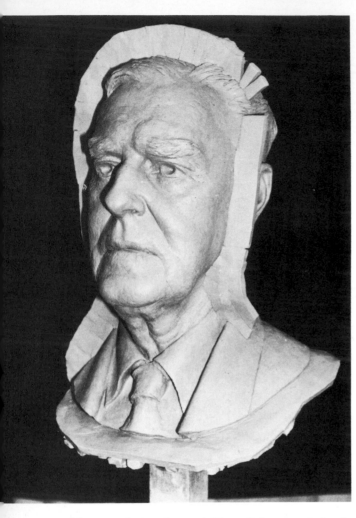

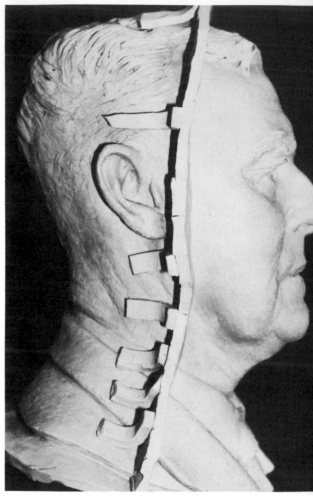

This side view shows the clay buttresses positioned to support the clay band in an upright position

After completing the modelling of the portrait head, a clay band is constructed to divide the head into two halves, in preparation for making the mould. The gap in the clay wall is to illustrate the method of construction using sections that are joined together to form a continuous band. Another strip has been constructed around the base of the bust to form a ledge. This makes a neat lower edge to the plaster mould.

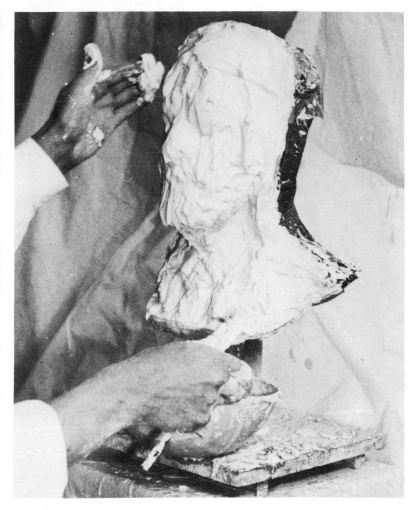

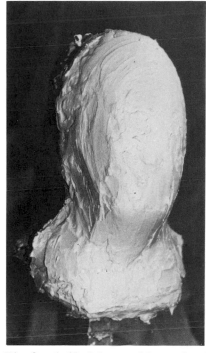

The first half of the mould completed

## Making the first half of the mould

Before commencing casting, the back of the head is covered with pieces of damp newspaper to protect it from splashes of plaster. A coloured layer of plaster is applied first. This acts as a guide when chipping away the mould at a later stage. The powder colour (in this case red iron oxide) is added to the water before the addition of the plaster. The plaster is then applied to the front of the head. Hold the bowl close to the sculpture, scoop out the plaster and make a flicking action with the fingers. Start at the top of the sculpture and work down. Blow hard to disperse any air bubbles, especially around the eyes, nostrils, mouth and ears. The photograph above shows the final layer of plaster being smoothed on by hand. No flicking action is required after the first layers of plaster have hardened around the clay model.

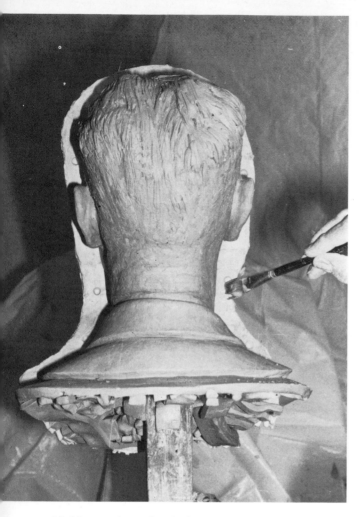

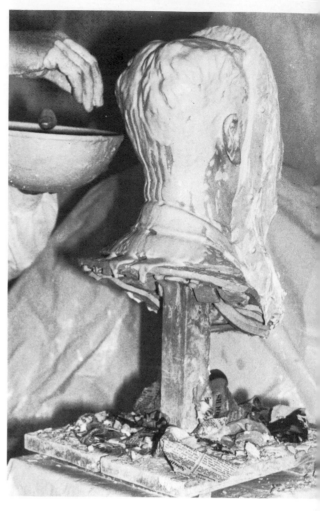

## Making registration holes

The clay walls and buttresses have been removed.
The photograph shows the shallow holes which have
been incised in the edge of the mould in order to key
with the other half of the mould. These registration
holes can be seen spaced equidistantly around the
mould edge. A separating medium (release agent) is
brushed over the mould edge and into the registration
holes to prevent the two halves adhering. A suitable
separating medium is a thin clay slip (clay dissolved in
water).

## Making the second half of the mould

The other half of the mould is cast in the same way as
the first half. Care should be taken to avoid any pockets
of air trapped around the ears. Plaster that accidentally
overlaps onto the first half of the mould should be
scraped off before it hardens.

## Opening the mould

After about an hour, when both halves of the mould have hardened, it is ready to be opened. The mould will not separate until the seam between the two halves is revealed all the way round. This is done by scraping or filing with a *Surform* rasp until a fine hairline seam is visible. The mould should then be submerged in water for about 10 minutes to assist in separating the mould halves. After removing from the water, the mould may be opened by inserting old wood chisels in the seam and gently prising the two halves apart. Remove the clay by taking as much from the centre as possible, preferably with a wood modelling tool. Then peel out the rest and carefully clean the inside of the mould. As this mould is to be filled with polyester resin and glass fibre, it must be dried out completely. The mould halves are reassembled, tied tightly and left in a dry, airy atmosphere for about three weeks.

## Release agents

The range of release agents suitable for portrait sculpture is somewhat limited. This is because it is necessary to use a compound that will not clog the fine detail of the hair, eyebrows etc. For this reason a liquid release agent such as *Johnson's Liquid Wax* or Tiranti's *Scopas Parting Agent* is most suitable. The use of an oil as a release agent with polyester resin is not recommended by manufacturers of glass fibre products. Nevertheless, linseed oil is used successfully by some sculptors, including Norman Pierce, FRBS, ARCA, SPS, whose methods are demonstrated in this section.

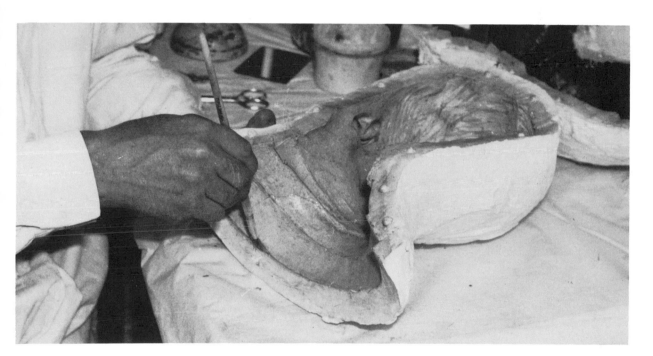

## Applying the release agent

Two applications of boiled linseed oil are painted onto each half of the mould and allowed to dry thoroughly. (Two thin coats of *Johnson's Liquid Wax* may be used as an alternative.) Next apply two thin coats of PVA (available from glass fibre or sculpture suppliers) and allow each coat to dry thoroughly. Make sure that the plaster edge of the mould is also treated.

## Cold cast bronze resin

The portrait was cast in a mixture of copper and brass metal filler in the ratio of 2:3, ie 500 g (18 oz) of copper and 750 g (27 oz) of brass, making a total of 1250 g (45 oz). The resin used is thixotropic resin. The total quantity of metal filler should be weighed before commencing work. It should be placed in a container, which should be shaken between each weighing of the filler, so that the result is uniform. Take 140 g (5 oz) of metal filler and place it in a suitable polythene mixing container. Add the resin gelcoat (approximately 1 heaped tablespoon) to make a substance liquid enough to be painted into the mould. It is important not to add too much resin as the object is to incorporate as much metal filler as possible into the resin. This achieves a convincingly bronze-like effect. To each heaped tablespoon of resin, 18 drops of hardener are now added and mixed in thoroughly.

*Note*　There is a wide range of metal fillers including brass, iron, aluminium, copper and lead. They may be used in exactly the same way as has already been described for bronze filler.

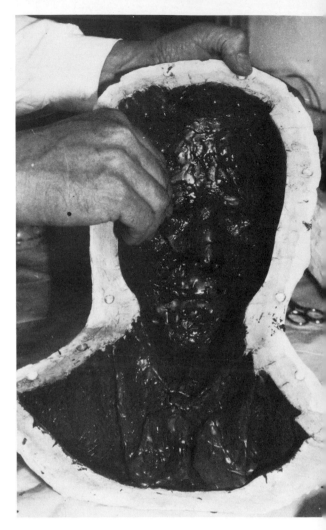

### Applying the gelcoat

Paint the metal/resin mixture into the prepared mould to a depth of approximately 3 mm ($\frac{1}{8}$ in.). Make sure that there is enough metal/resin in the mould to cover the high points. Paint right up to the edge of the mould. Additional metal/resin may be applied when the first coat has set

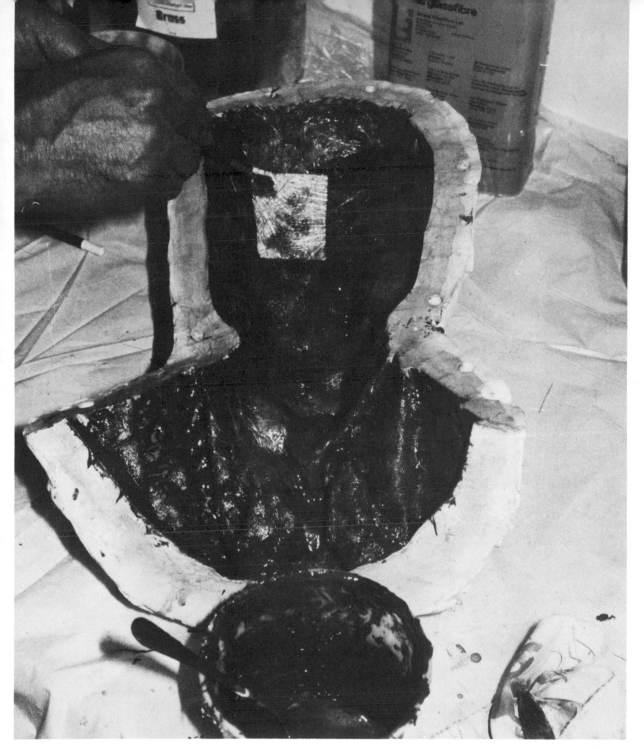

## Reinforcement of the cast
### with chopped strand mat

The cast is strengthened by the addition of glass fibre. Put 1 tablespoon of laminating resin into a container and add 8 drops of hardener. Mix thoroughly. Paint the mixture into a small section of the mould at a time. Place small pieces about 5 × 7 cm (2 × 3 in.) of glass fibre into the mould on top of the resin and stipple the resin through the matting onto the surface. Care should be taken to bed down the glass fibre on to the surface of the mould. This glass fibre reinforcement should be no closer than 5 mm ($\frac{1}{4}$ in.) from the edge of the mould. Two layers of glass fibre should be sufficient to strengthen the cast.

135

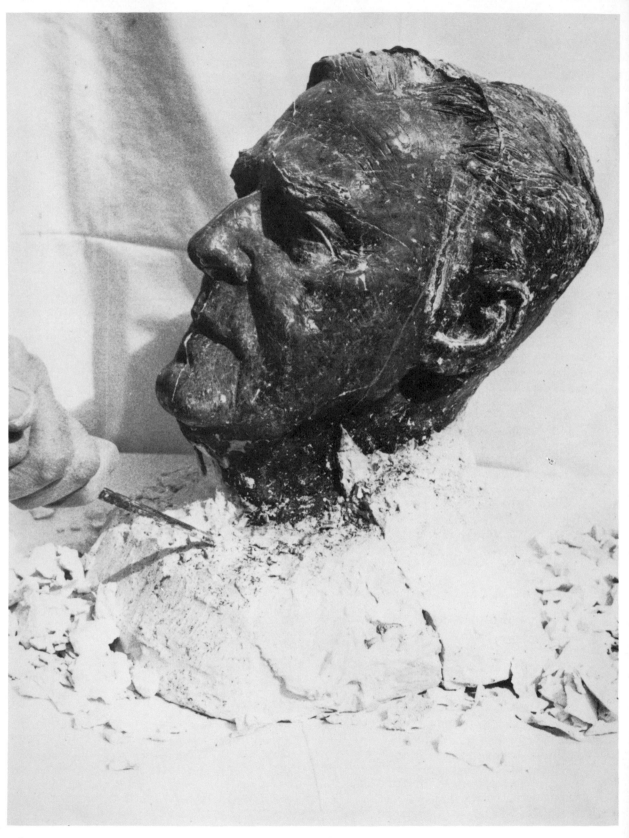

## Joining the mould halves

Put the 2 halves of the mould together and tie securely. Put clay or plasticine along the outside of the seam so that no metal/resin mixture can run through. Prepare some more of the metal/resin mixture and paint along the inside seam. If parts cannot be reached in this way, metal/resin mixture should be made up, using laminating resin and run down along the seam until it is totally covered. The seam is then reinforced with pieces of chopped strand mat, in the same way as for the 2 mould halves. When the cast has hardened, it should be placed in water overnight so that the plaster can soften. This soaking should facilitate the removal of the plaster mould.

## Removing the plaster mould (see opposite page)

When chipping away the mould, place it upright on a soft surface (such as thick rags) to cushion the blows. Chip away the back of the mould using a wooden mallet and a wood chisel of about 2 cm ($\frac{3}{4}$ in.) in width. Begin roughly where the crown of the head should be. Hold the chisel at right angles to the surface of the mould to prevent it slipping across the surface of the cast. Always keep the bevel towards you, so that the plaster splits towards the open space created by the previous cuts. Work round the back half of the mould, removing the plaster in layers. The coloured layer should act as a warning to the proximity of the cast. Do not chip away the plaster from around the neck. In this way, the mould will stand upright for as long as possible. Proceed to the front of the mould and with great care, chip away all the plaster over the face of the cast. Small pieces of plaster that remain around the features can be removed later with a small knife or chisel. Finally, chip away the plaster that remains around the neck.

## Cleaning up and making good the cast

The seam should be removed from the head by means of tools such as a wood carving gouge and bronze rifflers. Patching is best done by placing about half a teaspoonful of metal filler on a tile and adding some thixotropic resin to this. Mix to a paste and add 2 drops of hardener. A metal tool should be used for applying the mixture to the imperfections in the cast. Steel wool should be rubbed over the cast to bring out the quality of the metal. The seam generally shows lighter than the rest of the cast. To eliminate this difference rub over the entire cast with oak wood stain and quickly remove. Different coloured waxes can now be applied to the surface of the cast, depending on the result desired.

## Attaching a metal bolt

In order to attach the sculpture to a base it is necessary to laminate a bolt in position. This is attached by laminating 2 or 3 layers of resin-impregnated glass fibre over it

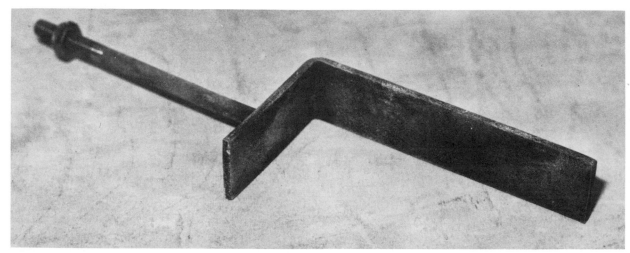

*The bolt used for this sculpture has been welded to a bracket*

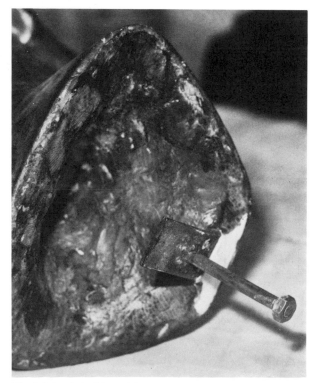

*The bolt laminated in position*

*The completed sculpture on a stone base.*
Portrait of Commander C A A Irvine *DSC, RN Retd*
*Norman Pierce FRBS*

## Resin bases

Bases can be made in resin combined with a filler powder such as slate powder, *ciment fondu* or stone dust and reinforced with chopped strand mat. The general procedure for making the plaster mould is described on pages 72–76, 130–133. The technique for laminating the resin and chopped strand mat is the same as described for casting the portrait head.

## Polishing and finishing metal/resin casts

When the cast comes out of the mould it has the appearance of dull plastic. In order to bring out the metallic quality it must be polished. Best effects are obtained by hand polishing. A mop attachment on an electric drill tends to remove some of the detail, although it is excellent on a flat, smooth surface. A metal polish such as *Solvol Autosol* is ideal for polishing by hand. On fairly large areas, fine wire wool may be used. Patinating metal/resin with acids is generally rather unsuccessful. However, it can be done, although the resistance of the metal/resin to acids make the patina rather light in colour. Good results can also be achieved by polishing the cast with heavily pigmented waxes (ie beeswax blended with powder colour, or shoe polish).

The detail of grey-coloured metal/resin casts can sometimes be enhanced by application of a black oil-based paint. Blackboard paint is often used for this purpose, as it has a matt finish. It should be painted over the cast and then immediately wiped off with a rag soaked in turpentine. This leaves the black paint in the recessed detail.

## Weighting glass fibre casts

The light weight of fibre glass casts, while being a great advantage with large sculpture, can be rather unsatisfactory for small sculpture. This particularly applies to metal/resin sculpture where the metallic appearance of the cast gives the feeling of weight, but when it is handled the lightness in weight is rather incongruous. For this reason some sculptors like to add extra weight to the sculpture. Iron filler, which is cheaper than any of the other metal fillers, makes an excellent material for adding weight. It should be mixed with resin and catalyzed in the same way as for preparing a metal/resin gel coat. This should then be poured into the cast to form a core. If a large area is to be filled in this way, it is likely that too much heat will be generated by the quantity of resin. To avoid this, flexible resin should be combined with the laminating resin (up to 50 per cent of flexible resin may be added to the laminating resin). Flexible resin can be obtained from fibre glass suppliers.

## Filling moulds solid

Very small moulds do not have sufficient mould surface to laminate with resin and glass fibre. In this case the mould can be filled solid. This is done by painting or pouring the coloured gel coat into the mould so that the inner surface is coated. When this becomes tacky the mould may be filled with a mixture of resin and the type of glass fibre that is sold for roof insulation. To prepare the mixture, catalyze the resin, then shred the insulation material and mix very thoroughly into the resin. When enough has been incorporated to make a doughy consistency, it should be tipped into the mould and tamped gently to remove pockets of air. Care is needed when filling moulds solid, as catalyzed resin generates a considerable amount of heat which may cause the cast to crack. Should this happen the mould should be plunged into water. It is also important to add the correct amount of catalyst, as too much will further increase the heat generated by the resin.

## Glass fibre moulds

These can be made by the laminating procedure already described for filling a mould. Mould divisions are made with plasticine and should be placed at such an angle that the pieces can be removed easily from the positive and the cast (ie no locking pieces). The original model must be treated with a release agent (see pages 63–64) to prevent the mould adhering. The following section shows a mould being made from the sculpture of a horse in glass fibre.

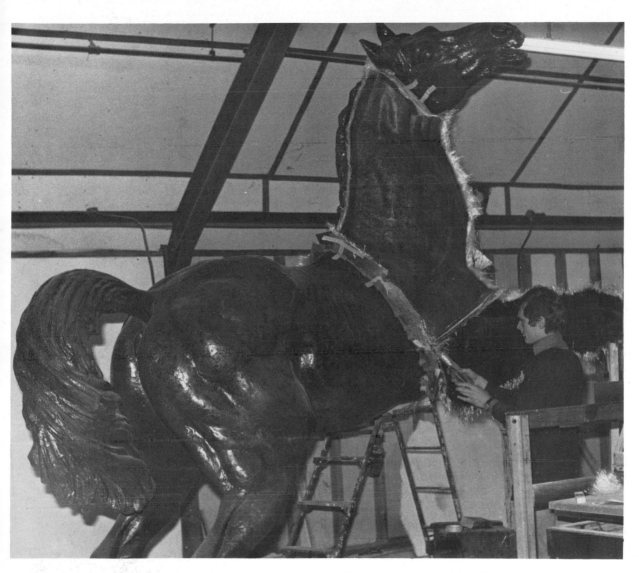

Place plasticine mould dividers in position. Masking tape is used to help keep the plasticine strip in an upright position. The mould of the horse's neck has already been laminated and the front leg section has been prepared by applying a thick coat of wax and then PVA as the combined release agent. When this has dried the mould area is brushed with a coat of catalyzed laminating resin

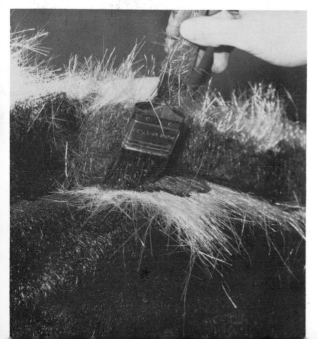

After the first layer of resin has gelled but is still tacky (the time this takes depends on the room temperature), the mould section is painted with another layer of resin, but this time pieces of chopped strand mat are placed in position and the resin stippled through until the mat is completely impregnated

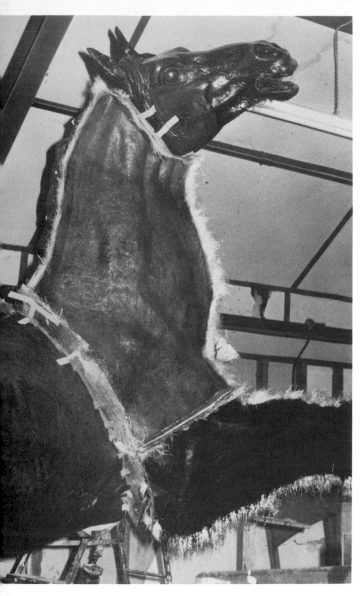

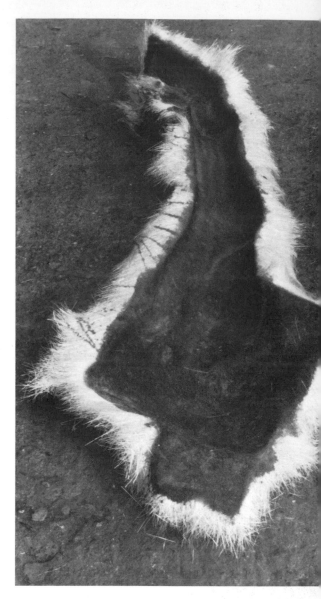

Two further layers of matting are then laminated, using the same stippling action. It is not necessary to wait for each layer to gel. Each piece of the mould is made so that the chopped strand mat extends beyond the mould edge. This ensures that the edges are properly laminated. The mould should then be left to cure for a day before it is removed

The mould is removed by flexing it away from the model. If there is any difficulty in removing it, water may be poured between the mould and the model to break the suction. Before filling the mould it must be treated with a release agent (see pages 63–64). It is then laminated with a gel coat (in which a colour pigment or metal filler is mixed) and two or three layers of glass fibre reinforcement

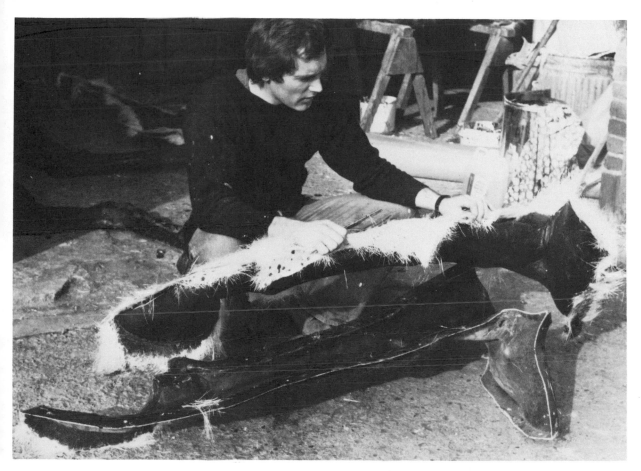

Remove the cast. When the cast has cured it is removed from the mould by inserting chisels between the mould and cast and gently flexing them apart

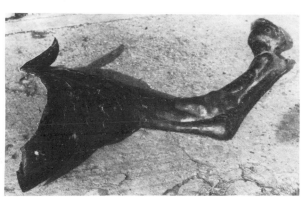

*The cast leg section of the horse*

The sculpture of the horse from which the mould was made was part of a larger work made by David Gillespie Associates, Farnham, Surrey.

# Some common faults

The table below shows some of the commonest faults that may occur when working with polyester resin and glass fibre. Possible causes and suggested remedies to prevent the fault being repeated are also listed.

| Fault | Possible causes | Suggested remedies |
|---|---|---|
| tacky surface | undercure of gel coat | check catalyst addition and efficiency of mixing |
| | insufficient catalyst | |
| | working conditions too damp | avoid operation under cold, damp conditions |
| blistering | air trapped between gel coat and lay-up (laminations) | apply generous layer of resin over gel coat so that on laying-up, air is forced through the glass mat |
| | contamination with water or solvent | ensure complete removal of cleaning solvents or water from brushes and rollers |
| fibre pattern *glass fibre shows through resin* | gel coat too thin | ensure even and adequate gel coat |
| | gel coat undercured | avoid applications under cold, damp conditions |
| | | allow adequate time for hardening a gel coat before commencing lay-up |
| | premature extraction of cast from mould | ensure adequate cure of cast before extraction |
| pinholing | air bubbles trapped in gel coat | avoid beating air into gel coat when adding catalyst or colour paste |
| | | lay gel coat with light, even strokes and avoid stippling action |
| | dust particles on mould surface | remove all traces of dust before laying gel coat |
| flaking gel coat | faulty adhesion between gel coat and layers of chopped strand mat | avoid leaving gel coated mould for longer than 12 hours before applying layers of chopped strand mat |
| distorted or discoloured areas | excessive exotherm | adjust accelerator/catalyst system |
| | | reduce thickness laid up at onc time – use lighter chopped strand mat (CSM) and more layers |
| delamination | insufficient resin | ensure even and adequate resin application |
| | poor wetting-out of glass mat with resin | |

# Water extended polyester resins (WEP)

WEP resins are a useful addition to the range of materials suitable for filling moulds.

WEP resins are special polyester resins which are readily emulsifiable with water and when cured are white in colour, and have the working characteristics of hard wood.

The resin may be pigmented before casting or the castings may be stained after curing to resemble wood carvings, etc.

Very fine detail is obtainable with suitable moulds, such as those made in latex rubber or silicone rubber.

To obtain a stable emulsion of resin and water the following instructions must be followed carefully.

## Equipment

2 polythene buckets
1 measuring cylinder
1 × 2·50 cm (1 in.) paint brush
Scales, preferably with metric weights
Mixer (may be mixer paddle used in electric drill)
Acetone for cleaning equipment

## Method

1 Weigh the amount of WEP resin required into one of the buckets and weigh the same amount of tepid water into the other bucket.
2 If pigment or filler is required it must be added to the resin at this stage.
3 With the mixer running in the resin, slowly add a small amount of water, drop by drop, until the resin turns milky, when the rate of water addition may be slowly increased until it has all been added and is completely emulsified with the resin. The emulsion if properly prepared should be stable for several days.
4 The emulsion should stand for 30 minutes to allow entrapped air to rise to the surface. Meanwhile, check that the mould is ready for use and has had release agent applied if required. (Not normally required with hot melt compounds, latex rubber or silicone rubber moulds.)
5 Add 2 per cent of catalyst to the emulsion and mix it gently with a stirring stick to avoid mixing in air.
6 Pour a small amount of the catalyzed emulsion into the mould and quickly brush it all over the surface, taking particular care to work it into any deep cavities. Then pour remainder to fill mould. Catalyst percentages are calculated on the resin weight only.

To 1,000 g WEP
add 1,000 g water
emulsify
add 2 per cent = 20 cc catalyst

Pigment pastes at the rate of 5 per cent and fillers at the rate of up to 100 per cent should be added before the water, if required.

The following table gives an indication of percentages of catalyst for given weights of WEP resin:

| up to 1 kg resin | 2·0 per cent catalyst |
|---|---|
| 1 to 3 kg resin | 1·5 per cent catalyst |
| over 3 kg resin | 1·0 per cent catalyst |

Users should experiment with catalyst percentages, as room temperatures and bulk of resin will affect cure time.

If pigments are used, the white emulsion will affect the colour shade, as also will any fillers used. This should be allowed for when choosing colours.

Fillers will increase the hardness and rigidity of castings.

*Reproduced by kind permission of*
*K & C Mouldings (England) Ltd*

# 11 Notes on some other casting techniques

It would be impossible to mention every type of mould making material and casting technique in the space of this book, so I have selected only those most likely to be useful to the reader. There are a few additional materials and techniques that I feel should also be mentioned briefly. The following notes are intended only to give the reader some idea of the scope available in the field of casting. For anyone interested in finding out more about any of these techniques, I have included books in the bibliography that deal more specifically with certain processes.

## Piece moulds

A piece mould is a plaster mould that may be used for making multiple casts. Most plaster moulds are 'waste moulds' because they are chipped away to get at the cast. A plaster piece mould is re-usable and can be kept indefinitely. The mould is made in several pieces to avoid the problem of undercutting. The pieces are carefully made to fit together and are held in place by a casing, usually made of scrim and plaster, which fits over the mould and locks the pieces.

## Hollow plaster casts

To make a hollow plaster cast, soak the plaster mould thoroughly and then apply the release agent (see pages 63–64). If the mould has been constructed in 2 or more pieces, assemble the mould, seal the seam with plaster and place strips of scrim soaked in plaster along the seams to hold the mould pieces together. Mix a batch of plaster and pour it into the mould. Rotate the mould so that the inside is coated with plaster. Pour out the residue, wait a minute or 2 for the plaster to thicken slightly, and repeat the process until the cast is about 2 cm ($\frac{3}{4}$ in.) thick. Reinforcement, such as scrim or glass fibre, dipped in plaster should be added to strengthen the cast. This should be pressed in to the plaster and a further batch of plaster mixed, rotated in the mould and poured out. After about an hour the cast should have set sufficiently hard for the mould to be chipped away. *Note* If a plaster cast is to be made from a plaster mould, it is important to add powder paint or some other water based paint, to the first layer of plaster when making the mould. This coloured layer prevents the plaster mould from being confused with the plaster sculpture at the chipping-out stage.

## Wax moulds

Wax is a useful material for making moulds. Microcrystalline wax (see sculpture suppliers) is generally used for this purpose. Wax moulds are rather fragile and are generally used for small sculptures. Wax should be melted in a large tin or saucepan in sufficient quantity to enable the sculpture to be immersed completely. This is done by suspending the sculpture on a thin thread and dipping it several times into the molten wax. Build up the wax thickness to between 0·5 and 0·75 cm ($\frac{1}{4}$ and $\frac{5}{16}$ in.) or thicker over larger forms. Leave to cool and harden. Remove a section of the mould by cutting through the wax with a sharp knife so that the clay is accessible. Soaking the mould in water will make the clay easier to remove. The mould section should then be replaced and sealed with molten wax or by smoothing the seam with a heated metal spatula. A small hole is made in the bottom of the mould, where it will not show, through which the casting material is poured. Warm the wax very slightly to remove the cast.

## Making moulds from the human figure

When casting directly from the life model it is wise for first attempts to start with a part of the anatomy that is not going to cause problems if the casting is unsuccessful. Leave the head till last! To cast a hand; first grease it thoroughly with *Vaseline*. It is a good idea to support the hand on a ball of clay to prevent muscle fatigue, then construct a clay fence around the hand. Warm water may be used to mix the first coat of plaster. Build up several layers of plaster over the hand. When the plaster has set, turn the hand over and make a mould of the other side. Remember to apply a separating medium. The completed mould halves can be separated by the model flexing the wrist. When filling the mould, remember to reinforce the fingers and thumb.

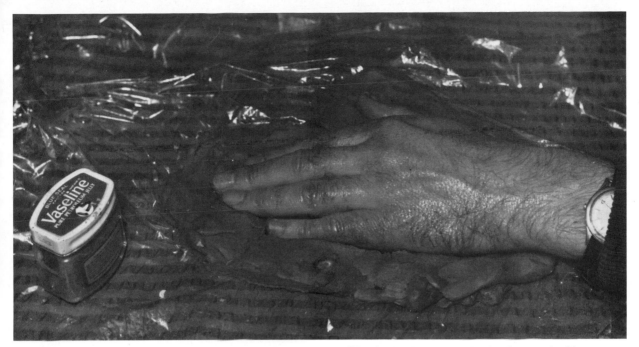

Build a clay band around the hand and grease the skin
with Vaseline. Make round registration holes (keyways) in the
clay using the end of a round handled knife

Cover the hand with a layer of plaster

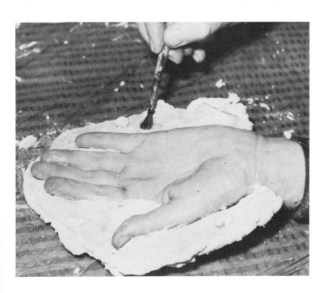

Carefully turn over the hand and plaster mould and
remove the clay band. Paint the plaster edge with clay water to
prevent the mould halves adhering. Grease the area of the hand
that is now visible and make the other half of the mould

# Moulds in expanded polyurethane and expanded polystyrene

Both these materials have already been described as materials for modelling sculpture. They are also available in a liquid form which expands, when mixed with a foaming agent, to many times its original volume. The cellular material formed contains up to 80 per cent air.

This expanding action can be utilized as a technique for making moulds from very simple shapes. The original sculptural form is set in a container (eg a large box) and the liquid and foaming agent, previously well mixed, are poured in. The foam expands around the form. When the reaction is complete and the foam is set, the original sculpture can be removed by cutting the mould with a sharp knife or heated wire.

An alternative method of constructing a mould is to use strips and blocks of expanded polystyrene or expanded polyurethane. These can be cut to shape and stuck together. The only disadvantage is that the sculptor is working 'in negative' all the time and so has to visualize the way the sculpture will eventually look in its positive form. This material is often used to make moulds for relief panels. Cement or plaster is poured in and when it has set, the mould of expanded polystyrene or expanded polyurethane is burnt away. This should be done out of doors. The rough cellular texture of these materials is reproduced on the surface of the cast and can add an interesting quality to the work.

## Instructions for use of polyurethane foam resin

Polyurethane foam resin is supplied as two liquid components, part A and B and when mixed together in equal quantities will produce a closed-cell rigid foam, weighing 1 kg per cubic foot, which sets in approximately 15 minutes.

## Method of use

1    Weigh equal quantities of each component (A and B) into separate, clean containers, making allowance for the weight of the containers
2    Pour the two weighed materials into a clean polythene bucket and *immediately* start mixing with an electric drill fitted with a mixer paddle (speed approximately 1,500 rpm). Mixing should continue for 10 to 15 seconds
3    Pour the mixed foam into the cavity to be filled
4    Clean the mixer paddle in acetone

To obtain the maximum volume of foam (ie 1 cubic foot of foam per kilo of mixed components), the following conditions should be observed:
i    Working temperature should be approximately 20°C (68°F). Low temperatures retard the reaction of the two materials.

ii    Mixing must be quick and complete. Mixing by hand with a stick will not produce the best foam.
iii    Mixing should not be continued after the material has a creamy appearance.
iv    Pouring into a deep, narrow cavity will restrict the rise of the foam, owing to friction between the foam and the walls of the cavity. It is better to fill with several small mixes, allowing each mix to rise and harden before pouring the next.

Foam shapes may be produced by pouring the mix into wood or glass fibre moulds using *Vaseline* as a release agent.

## Handling

Gloves or *Kerodex 71* barrier cream, should always be used when handling polyurethane foam resins. The use of eye shields is also recommended.

Should skin contact occur, the material should be removed using *Kerocleanse 22* and finally washed with soap and water.

Avoid inhaling the vapour from the materials, particularly during foaming.

Use under well-ventilated conditions only. When the material has set it is safe.

## Storage

Both materials (A and B) must be stored under cool conditions in airtight containers.

*Reproduced by courtesy of*
*K & C Mouldings (England) Ltd*

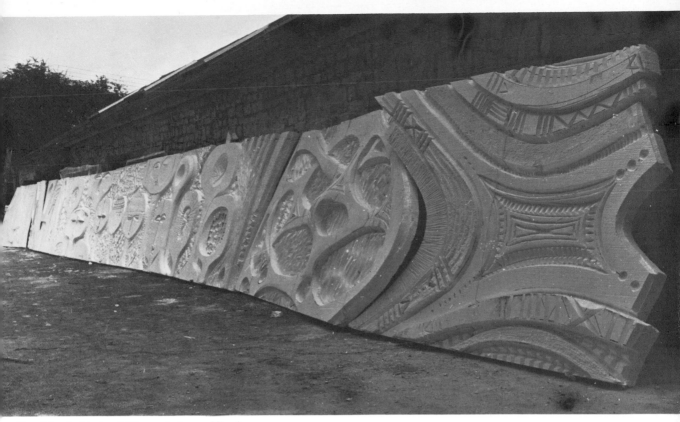

*Mural for the National Theatre in Lagos, Nigeria.*
*The panels were made in polystyrene and then cast in glass fibre by Gillespie, Farnham, Surrey*

## Low melting point alloys

There are a number of low melting-point metal alloys on the market (see suppliers' list). These are often used for making jewellery. They are expensive and are generally used for casting very small sculpture. Their advantage is that they can be melted on a domestic cooker in a small cast iron crucible. When they are poured into a plaster mould, it is essential that the plaster is perfectly dry, otherwise it is likely to explode and throw out molten metal. It is often advised that the mould is first dusted with graphite powder. However, the manufacturer's directions should always be followed, as different alloys require different methods of treatment.

## Lead and pewter

These metals (pewter is an alloy of tin and lead) have a low melting-point and can be melted on a gas or electric ring. Lead can be bought from a scrap yard or builder's yard. Sculpture in lead has a dull, grey shine that can be quite pleasing. Pewter can also be used for casting small sculpture. The best way of obtaining pewter is to look round junk shops for old, battered pewter which can then be melted down. Thin sheets of pewter can be bought from some craft shops.

## Bronze casting

Sculptors requiring their work cast in bronze generally go to an established bronze foundry. (Addresses are given on page 157). Some sculptors may set up their own foundries but this requires specialized knowledge.

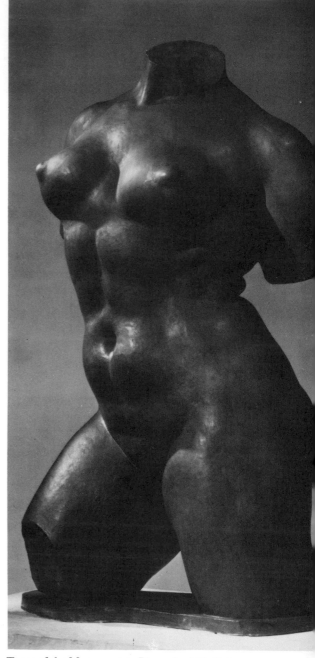

Torso of the Monument to Blanqui. *A Maillol. Lead. Tate Gallery, London*

# Glossary

*Aggregate*   The inert or body-supplying ingredient that is mixed with a cement in making a casting mix such as concrete.

*Air bath*   A method of heating a compound in a double vessel by surrounding it with hot air instead of hot water.

*Alloy*   A combination of two or more metals.

*Armature*   A supporting framework upon which may be modelled a work in clay, plaster, wax, etc.

*Artificial stone*   A type of cast stone usually made from cement and stone dust.

*Batten*   A strip, slat of wood.

*Bedding in*   The method of filling the surrounding space between the model and the casing with clay when making a rubber mould.

*Bloom*   The white deposit on a *ciment fondu* cast after removal of a plaster mould.

*Bronze*   A compound of copper and tin to which are sometimes added other metals, particularly zinc.

*Bronzing*   A term to describe the process of colouring a plaster cast in imitation of bronze. It is also used to describe methods of giving a bronze appearance to other metals and non-metallic materials.

*Bust peg*   A length of wood attached vertically to a flat, wooden board to form the basic structure on which a bust may be modelled.

*Butterfly*   Two pieces of wood bound together with wire to form a cross. Butterflies are suspended from an armature to support the weight and prevent excessive sagging of the clay.

*Cap*   A small section of the mould that is separate from the main part and acts rather like a lid. This provides access to the inside of the mould for the removal of clay and for filling the mould with the casting material.

*Cast*   A work that has been produced by means of a mould.

*Casting*   A reproductive mechanical process whereby the form of an object is reproduced in another, generally more durable, material.

*Cast stone*   See artificial stone.

*Catalyst*   A chemical compound used to initiate the curing of a polyester resin and silicone rubber.

*Cement*   A binding material with which concrete is made.

*Chipping out*   Removing the waste mould from a cast by means of a hammer or mallet and chisel.

*Chisel*   A carving tool, generally made of steel with a hard end for cutting and a blunt end which receives the blow from the hammer or mallet.

*Chopped strand mat*   A matting made from glass filaments, chopped into approximately 50 mm strands which are held together with a resin-acceptable binder.

*Ciment fondu*   A quick-setting cement.

*Clay*   Tenacious earth which may be modelled.

*Clay band*   Strip of clay used to make divisions between sections of a mould.

*Clay buttress*   Wedges of clay positioned behind a clay band to keep it in an upright position.

*Clay film*   The deposit that remains on the mould surface after the removal of the clay model.

*Clay water*   A solution of clay and water to the approximate consistency of milk. This is used as a separator to prevent sections of the plaster mould from adhering to one another.

*Clay wedges*   Pieces of clay that are positioned on the model so that they form slots between the sections of the mould. This makes it possible for water to be poured into the mould to facilitate opening.

*Cold metal resin casting*   The technique of making a simulated metal cast from polyester resin and a metal filler.

*Cold cure silicone rubber*   A flexible mould making material that solidifies when mixed with a catalyst.

*Colour paste*   A polyester pigment suitable for colouring polyester resin.

*Concrete*   A mixture of cement, sand, aggregate and water.

*Countersink*   To enlarge top of a drilled hole so that the head of a screw or bolt is recessed.

*Crystacal*   A grade of casting plaster that sets very hard.

*Cure*   The period of setting time during which a material such as concrete or resin achieves maximum hardness.

*Damp box*   The enclosing container, usually made from wood slats and polythene sheeting, for keeping clay work damp.

*Delamination*   The breakdown of the structure of a polyester resin and glass fibre laminate by the separation of the layers.

*Dwell time*   The period of time during which a model is left immersed in a casting compound.

*Emulsion*   A liquid mixture of one or more compounds.

*Exotherm*   An increase of temperature which results from the chemical reaction in the curing of polyester resins.

*Expanded metal*   A metal mesh used to reinforce concrete.

*Expanded polyurethane*   A compact type of foam plastic.

*Expanded polystyrene*   A foam plastic composed of bead-like granules.

*File*   An abrading tool made of metal.

*Filler*   A substance incorporated in a resin mix and designed to modify its structure.

*Firing*   The process of baking earth clay in a kiln.

*Flexible mould*   A mould made from a material such as rubber or glass fibre which allows the cast to be removed without destroying the mould.

*Flood mould*   An open mould generally of the type made for casting a relief.

*French chalk*   Powdered talc or magnesium silicate.

*G4 varnish*   A one-component plastic resin varnish, adhesive and sealer.

*Gelcoat*   The first application of unreinforced resin. It is usually pigmented or mixed with some type of filler.

*Gel time*   The time taken for the resin to set to a non-fluid gel; sometimes called a setting time.

*Goo*   A mixture of *ciment fondu* and water to make a paste-like consistency.

*Gouge*   A type of chisel with a curved cutting edge.

*Graphite*   A crystalline form of carbon. Also called black lead or plumbago.

*GRP*   Glass reinforced plastic.

*Green*   A term used to describe glass reinforced polyester resin after catalization, when it has become a non-fluid gel but before it has set hard.

*Gypsum*   A hydrated calcium sulphate; mineral from which plaster of paris is made.

*Herculite*   A hard-setting type of plaster.

*High alumina cement*   A quick-setting type of cement also known as *ciment fondu*.

*Hot melt compound*   A PVC based flexible mould making material.

*Hygroscopic*   Absorbs water from the atmosphere.

*Irons*   The term used to describe the reinforcement made from mild steel that is used for moulds and casts.

*Joiner's dog clamp*   Three-sided metal device that is hammered into position to clamp sections of a mould together.

*Key, keyway*   The method of registration for accurately assembling one mould section with another using a male and female locating device.

*Laminating, laying-up*   The process of impregnating the glass fibre matting with resin, in or on a mould.

*Leather hard*   The state of clay before it becomes dry.

*Mallet*   A wooden hammer.

*Maquette*   A three dimensional sketch model.

*Medium*   The vehicle, material, or instrument employed by the artist. The word is most frequently used in referring to materials (plural: media).

*Melting point*   The temperature at which the solid and liquid state of a substance are in a condition of equilibrium.

*Metal dogs*   Three-sided length of metal, bent at rightangles, which is hammered into position to hold sections of a plaster mould tightly together

*Model*   An original work, generally made from a plastic material.

*Modelling*   The act of fashioning a work from a plastic material.

*Mould*   The negative form in which an object is shaped or cast.

*Mould case*   A reinforcing shell generally made from plaster or glass fibre which supports flexible moulds made from silicone rubber, latex and hot melt compounds.

*Mould divider*   The wall or fence, usually of clay or brass, that separates the sections of a mould.

*Multi-piece mould*   A mould that has been constructed in a number of sections.

*Multiples*   A number of identical objects.

*Negative*   The shell-like impression or mould into which the positive casting material is poured or pressed.

*One piece mould*   A mould made in one piece.

*Parting agent*   The material applied to surfaces in order to prevent them adhering to one another. (Also known as a release or separating agent.)

*Patina*   A term generally used to describe the finish or colour formed on metals or metallic alloys by natural causes, such as the atmosphere or by artificial means, such as the application of acids.

*Piece mould*   A mould made in several pieces over a model in order to preserve the original in an undamaged condition. A mould of this type, made in several sections, allows many positive casts to be taken.

*Plaster of paris*   A fine white powder made from gypsum that sets hard when mixed with water. Used for working direct and for making moulds.

*Plastic*   Capable of being shaped by modelling, moulding or casting.

*Polyester resin*   A synthetic resin.

*Polymerize*   A chemical reaction in which small molecules join together to form a large molecule.

*Portland cement*   A type of cement simulating Portland stone.

*Pumice*   A material made from lava that has been aerated by escaping gases. Used as a filler in polyester resin and for smoothing and polishing stone.

*PVA*   Polyvinyl acetate.

*PVC*   Polyvinyl chloride.

*Reinforcement*   The method by which a material is strengthened by embedding in it a stronger material, such as mild steel.

*Release agent*   See parting agent.

*Relief*   A design made on or in a flat surface.

*Retaining wall*   A wall constructed around a sculpture to retain a liquid mould-making material while it is setting.

*Riffler*   A straight metal filing tool, usually with abrasive surfaces on each end. Useful for abrading awkward or detailed parts of a sculpture made in wood, stone, plaster of paris, metal, resin, etc.

*Risers*   The channels made in a mould or mould case to allow air and gases to escape.

*RTV 700*   Room temperature vulcanising silicone rubber compound used to make moulds.

*Scrim*   A coarse woven fabric, usually made from jute, used to reinforce plaster of paris.

*Seam*   The division between pieces of a mould.

*Shelf life*   The time during which a material may be stored under specified conditions and remain suitable for use.

*Shellac*   A varnish made from the resinous secretion of an insect.

*Shim*   The brass fencing used to make the divisions of a waste mould.

*Shuttering*   A mould constructed in situ, usually in wood, into which concrete or plaster may be poured to make a casting.

*Skin mould*   A thin rubber mould made by coating the model with the liquid compound and allowing it to set.

*Slip*   Dry earth clay that has been pulverized to a fine powder and then mixed with water to the consistency of thick cream.

*Soft soap*   A semi-liquid soap used as a release agent.

*Spatula*   A flat tool, usually of wood or metal, designed in a variety of shapes for working materials such as clay and plaster.

*Stippling*   The up and down, jabbing movement of the brush used to impregnate glass fibre mat with resin.

*Surface mat*   A thin fibre tissue placed on one or both sides of a mould to improve the surface.

*Surform file*   The trade name of a type of rasp that has holes cut in its surface. Used to rasp wood, soft stone and plaster.

*Tamping*   The act of consolidating a granular material such as concrete.

*Terracotta*   Baked earth.

*Thixotropic*   The condition of a fluid of high apparent viscosity, which when applied to vertical surfaces, will not drain.

*Undercut*   The part of a three dimensional object or mould that prevents the safe and easy removal of a positive impression or of a negative mould.

*Viscous*   Having a syrupy consistency.

*Waste mould*   A negative mould which is chipped away from the positive cast.

*Water wet*   To prepare by thoroughly soaking in water so that air pockets in material are filled with water.

*WEP*   Water expanded polyester resin.

*Wetting down*   Spraying a clay sculpture with water to keep it moist.

# Bibliography

**Casting Techniques**
*The Materials and Methods of Sculpture*, Jack Rich, Thames & Hudson
*Creative Casting* (Jewellery, silverware, sculpture), Sharr Choate, Allen & Unwin
  (includes section on casting in metal alloys)
*Glass Fibre for Schools*, John Tiranti, Alec Tiranti, London
*Sculpture in Glass-fibre*, John Panting, Lund Humphries
*Plaster Casting*, Victor Wager, Alec Tiranti, London (includes section on casting from life)
*Figure Sculpture jn Wax and Plaster*, Richard McDermott Miller, David and Charles
*Studio bronze casting – lost wax*, John W. Mills and Michael Gillespie, Maclaren & Sons
*The Technique of Sculpture*, John W. Mills, Batsford

**Anatomy and Modelling**
*Anatomy: A complete guide for Artists*, Joseph Shepherd, Pitman, London
*A Handbook of Anatomy for Art Students*, A. Thompson, Clarendon Press
*Anatomy and Figure Drawing*, Louise Gordon, Batsford
*Drawing the Human Head*, Louise Gordon, Batsford
*Head and Figure Modelling*, John W. Mills, Batsford

**History and Appreciation of Sculpture**
*The Art of Sculpture*, Herbert Read, Faber & Faber
*A Concise History of Modern Sculpture*, Herbert Read, Thames & Hudson
*Sculpture. The Appreciation of the Arts/2*, L. R. Rogers, Oxford University Press
*The Hand and the Eye of the Sculptor*, Paul Waldo Schwartz, Pall Mall Press
*Origins of Modern Sculpture: Pioneers and Premises*, Albert E. Elsen, Phaidon
*The Language of Modern Sculpture*, William Tucker, Thames & Hudson
*Beyond Modern Sculpture*, Jack Burnham, Allen Lane. The Penguin Press, London
*Henry Moore*, John Russell, Allen Lane. The Penguin Press, London
*Henry Moore to Gilbert & George*, Tate Gallery
*Three-dimensional design: a cellular approach*, Richard Thomas, Van Nostrand Reinhold
*Design through Discovery*, Marjorie Elliot Bevlin, Holt, Rinehart and Winston
*Visual Aesthetic* J.J. de Lucio-Meyer, Lund Humphries

# Suppliers

## Great Britain

### Sculpture suppliers *for tools, equipment and many of the materials listed below*

Alec Tiranti Limited
70 High Street
Theale
Berkshire

and

21 Goodge Place
London W1

### Clay

Fulham Pottery Ltd
210 New Kings Road
London SW6

W. Podmore and Sons Ltd
Caledonian Mills
Shelton
Stoke on Trent

### Plaster

Builder's merchants
Boots Chemists

### Stolit

The White Sea
   and Baltic Company Ltd
Patman House
George Lane
South Woodford
London E18

### Cement and ciment fondu

Builder's merchants

### Hot melt compounds

*Vinamold* and *Gelflex*
Head Office
Strand Glassfibre Limited
Brentway Trading Estate
Brentford
Middlesex

*Branches in every major city*

*Gelflex*
K & C Mouldings (England) Ltd
Spa House
Shelfanger
Nr Diss
Norfolk

### Expanded polystyrene and expanded polyurethane

Baxenden Chemical Company Ltd
Paragon Works
Baxenden
Accrington
Lancashire

Strand Glassfibre Limited
Head Office
Brentway Trading Estate
Brentford
Middlesex TW8 8ER

K & C Mouldings (England) Ltd
Spa House
Shelfanger
Nr Diss
Norfolk

### Latex rubber

K & C Mouldings (England) Ltd
*address above*

### Cold cure silicone rubber

K & C Mouldings (England) Ltd
*address above*

Eurosil Limited
E-Sil Works
Newmans Lane
Alton
Hampshire

Strand Glassfibre Limited
*address above*

### Glass fibre

Strand Glassfibre Limited
*address above*

K & C Mouldings (England) Limited
*address above*

### Polyester pigments and metal fillers
*for mixing with polyester resin*

Llewellyn Ryland Limited
Haden Street
Birmingham B12 9DB

### Waxes

Candle Makers Supplies
28 Blythe Road
London W14

### Metal alloys

Fry's Metals Limited
Tandem Works
Merton Abbey
London SW19

### Bronze foundries

The Morris Singer Foundry Limited
Bond Close
Kingsland
Basingstoke
Hampshire

Burleighfield Arts Limited
Burleighfield House
London Road
Loudwater
Buckinghamshire

### Sculpture Courses

West Dean College
West Dean
Chichester
Sussex PO18 0QZ

*Many of the suppliers listed above supply comprehensive catalogues and technical leaflets.*

## Suppliers *continued*
## USA

Mail-order catalogs obtainable on
request from:

Art Brown and Brothers Inc
2 West 46 Street
New York, NY 10036

Sculpture Associates Ltd
114 East 25 Street
New York, NY 10010

Sculpture House
38 East 30 Street
New York, NY 10016

Sculpture Services Inc
9 East 19 Street
New York, NY 10003

For further names and addresses
consult your Yellow Pages

# Index